1988

CREATIVE PAINTING OF EVERYDAY SUBJECTS

CREATIVE PAINTING OF EVERYDAY SUBJECTS

Ted Smuskiewicz

WATSON-GUPTILL PUBLICATIONS/NEW YORK

I thank Elaine J. Murray
of Wonder Lake, Illinois,
for her sincere efforts and
fine work in photographing
my paintings for this book.

I would also like to thank
Bonnie Silverstein,
senior editor at Watson-Guptill,
for her encouragement
and suggestions.

*To my wife, Dorothy,
herself an artist,
who always believed in me
and gave me much encouragement
and support while I worked
on this book.*

First published 1986 in New York by Watson-Guptill Publications,
a division of Billboard Publications, Inc.
1515 Broadway, New York, New York 10036

Library of Congress Cataloging-in-Publication Data

Smuskiewicz, Ted, 1932–
 Creative painting of everyday subjects.

 Includes index.
 1. Painting—Technique. I. Title.
ND1500.S58 1986 751.45 86–13253
ISBN 0–8230–1094–5

Distributed in the United Kingdom by Phaidon Press Ltd.,
Littlegate House, St. Ebbe's St., Oxford

Manufactured in Japan

First printing, 1986

Contents

Introduction

Every day each of us sees and experiences any number of quite ordinary things that have the potential of being good subjects for paintings. The purpose of this book is to help you learn to see and recognize these subjects and to develop the skills that will enable you to turn them into paintings.

You will be guided from the basic principles of learning to see and to recognize a good subject through the initial development of the composition with line, tone, and color. You will see how expressive oil painting techniques may be used to better enable you to depict your feelings in your work and how to use these techniques in such individual subjects as outdoor scenes, interiors, scenes including people, night scenes, and scenes done from memory.

I think that to some extent most people respond with their feelings to what they see. The student, or the not-too-experienced painter, however, often has some difficulty in developing a painting so that it clearly expresses a personal impression of the subject. The difficulty is not so much in becoming inspired about something but rather in having the skills necessary to develop and successfully communicate that inspiration.

Although the painter must be guided by sound principles of composition and technique in the development of a successful picture, it is still necessary to rely in part on personal feelings and response to the subject. The same subject may have an entirely different effect on several different painters. When we look at something, it is not only the subject itself that impresses us but also the many different balances of line, tone, color, and other things that give the subject its appearance. These many different balances have a direct effect on how we feel or respond to a subject. Knowing, then, how to use these different balances of line, tone, and color will help the painter to paint a subject as he or she truly sees it.

The sound principles and techniques that are shown in this book should not be merely copied; they should be used to develop and enlarge your individual skills. They are meant to serve not only as a guide but to help strengthen your ability to express your individual ideas in your painting.

Chapter One

LEARNING TO SEE AND APPRECIATE A SUBJECT

Almost anything, if certain conditions are right, can make an interesting subject for a good painting. Wherever you are, there are good things waiting to be painted; it is not necessary to search far and wide. An ordinary, everyday occurrence, such as going down to the corner store, stopping for a quick bite at some local luncheonette, taking your car in for servicing at the neighborhood garage, or shopping for fresh vegetables at a farmers market, can provide excellent and accessible material for good paintings.

If you approach nature, or life, with a preconceived idea of what you are looking for, you will probably have difficulty finding it. However, if you look around with a clear eye and an open mind wherever you are, you will become aware of the many everyday, yet interesting, subjects around you. An artist must be continually alert and aware, ready to recognize a good subject for a painting. Although everyday life continually offers subjects of interest to the painter, some degree of effort is required in order to put these to use.

ALMOST ANYTHING CAN MAKE AN INTERESTING SUBJECT FOR A GOOD PAINTING.

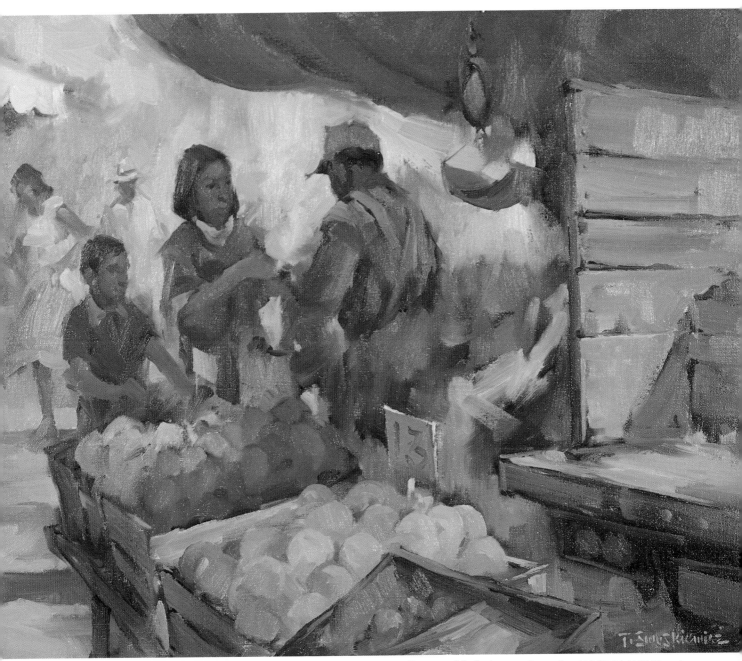

Farmers Market, 1985. Oil, 16″ × 20″ (40.64 × 50.80 cm)

One of the first things to recognize in a possible subject is the main idea, feeling, or effect. When we see something that impresses us, whatever the subject may be, it appears that way because of a certain arrangement and balance between its different parts. These parts are not only the individual components of which the subject is made, such as, in this case, the people, the awning, the table with boxes of vegetables, the foreground and background, but also the whole dark and light tonal arrangement as well as the balance of color.

Although life has much to offer the painter in the way of interesting subjects, the artist must still rely on his or her personal response to what is seen.

There Are Three Important Factors
That Influence a Subject's Appearance

1. THE EFFECT OF LIGHT AND ATMOSPHERE

2. THE ARRANGEMENT OF DARK AND LIGHT

3. THE HARMONY AND BALANCE OF COLOR

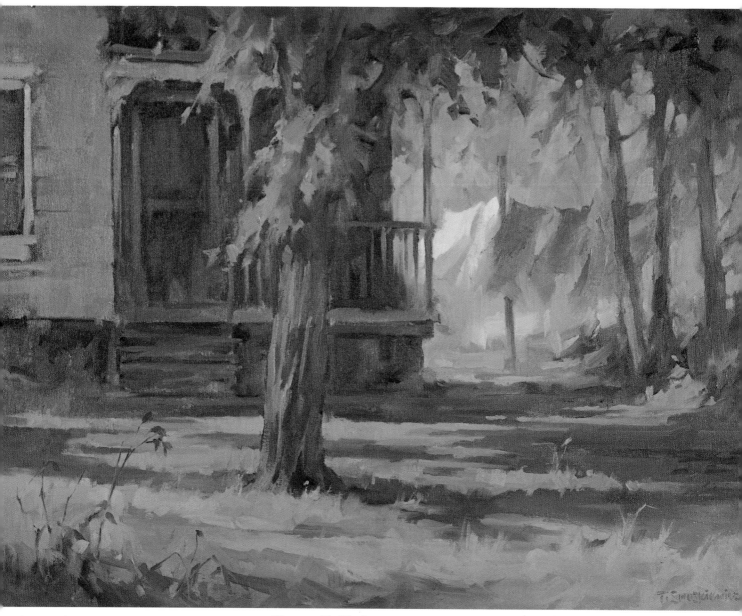

House with Wash, 1984. OIL, 18″ × 24″ (45.7 × 50.8 cm)

1. Not only does light (atmosphere) give the viewer a first, strong impression of the subject but it is also responsible for the appearance of the dark and light arrangement as well as the color effect.

When we look at any given scene, the effect of light and atmosphere is probably the first thing we see. We see a subject because of the way the light illuminates it and creates a certain arrangement of dark and light tones. Light also influences the harmony and balance of colors. The arrangement of the darks and lights and the balance of colors are the compositional building blocks that allow us to control the development of a painting. These tonal and color factors, which strongly influence a subject's appearance, can be used as is or changed by adjusting them somewhat.

The picture's basic effect can be achieved in the beginning stages of painting with the dark and light arrangement. This, plus the correct color harmony and balance, sets the mood and feeling of the finished painting. When looking for a subject to paint, keep these two points in mind.

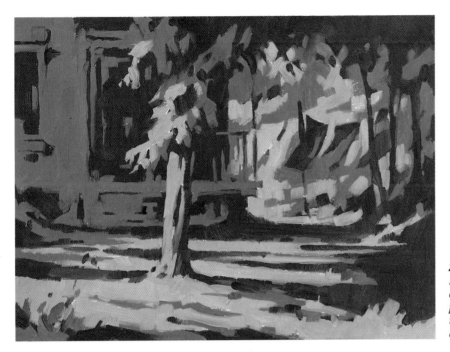

2. The arrangement of darks and lights is the basic foundation on which a painting is constructed. Every painting depends on a good underlying dark and light arrangement.

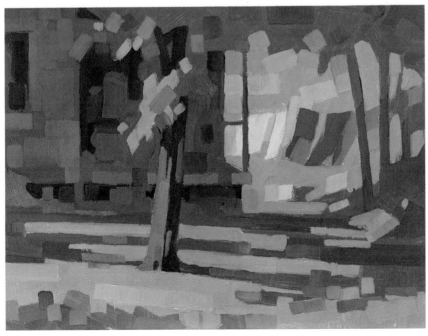

3. The correct color harmony and balance strongly affects the picture's appearance and contributes greatly to any mood or feeling depicted.

The Factors That Influence a Subject's Appearance Can Be Used as Is or Changed

The subject's underlying arrangement of darks and lights greatly influences the final appearance of a painting. A different appearance and over-all effect can be achieved in the same subject by changing this arrangement. Study and analyze the darks and lights in a prospective subject to see if there is any adjustment or change necessary. Squinting with half-closed eyes while you look at a scene will help you see its basic dark and light arrangement.

Although the arrangement of darks and lights has a basic influence on a subject's appearance, color also does much to create certain effects and feelings in a painting. Sometimes, as in the case of the pictures shown on these pages, an entirely different ef-

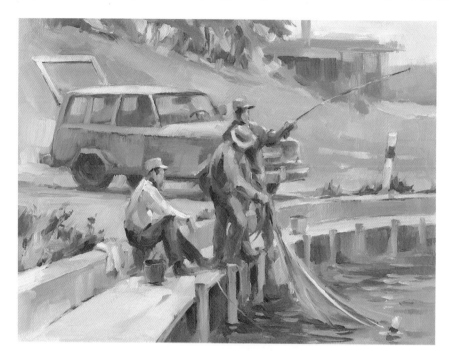

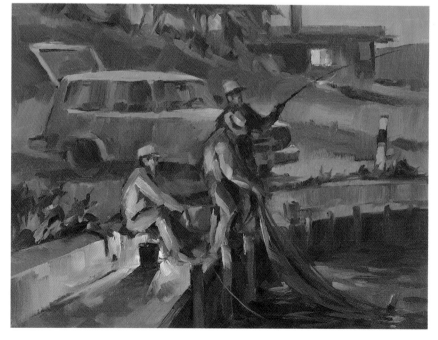

Although both these illustrations are of the same subject and have the same basic arrangement, changing the way the dark and light tones are used gives each an entirely different appearance.

fect of light can be obtained with the same subject by changing its dark and light tonal arrangement and also its color harmony. Other subjects may require only a slight adjustment in tone and color to show more clearly a desired effect.

Before beginning a painting, study your subject carefully to better understand its color harmony and balance. Since color has a strong and direct effect on how a painting looks, changing the color harmony and balance will change the way it appears. However, keep in mind that it is not always necessary to change both tonal and color arrangements. A painting can be improved by altering only the darks and lights or the colors.

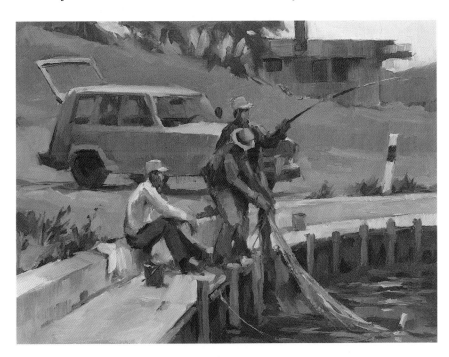

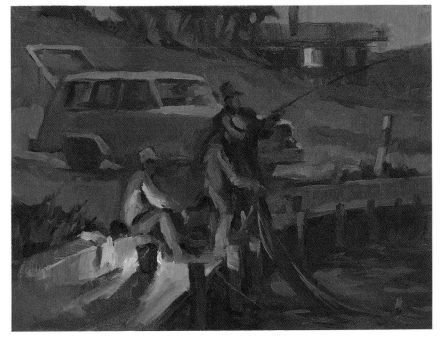

By also changing the way color is used, again with this same subject, a much stronger and different effect is achieved. The darker tonal arrangement combined with cooler colors now gives this subject a definite night effect.

Using a Viewfinder as an Aid to Seeing

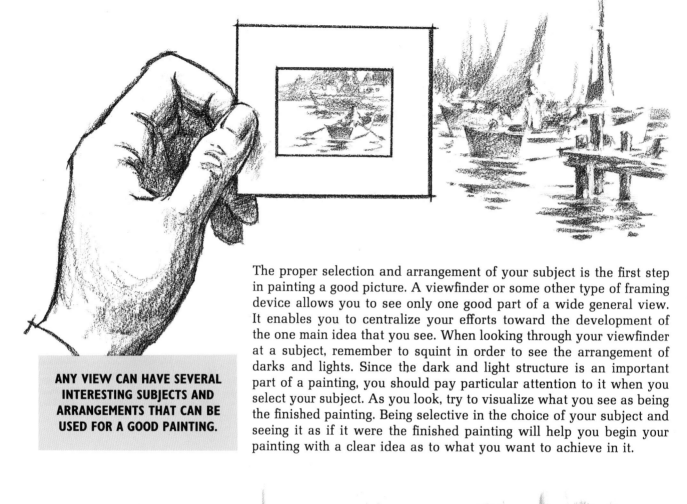

ANY VIEW CAN HAVE SEVERAL INTERESTING SUBJECTS AND ARRANGEMENTS THAT CAN BE USED FOR A GOOD PAINTING.

The proper selection and arrangement of your subject is the first step in painting a good picture. A viewfinder or some other type of framing device allows you to see only one good part of a wide general view. It enables you to centralize your efforts toward the development of the one main idea that you see. When looking through your viewfinder at a subject, remember to squint in order to see the arrangement of darks and lights. Since the dark and light structure is an important part of a painting, you should pay particular attention to it when you select your subject. As you look, try to visualize what you see as being the finished painting. Being selective in the choice of your subject and seeing it as if it were the finished painting will help you begin your painting with a clear idea as to what you want to achieve in it.

Making and Using a Viewfinder. *An adjustable viewfinder can easily be made by cutting two L-shaped pieces, approximately 4" long, out of a piece of heavyweight gray paper. Fasten these two pieces together with ordinary paperclips placed at diagonally opposite corners. Adjust the viewfinder for use by closing one eye and looking through it with the other eye at the canvas or panel that you will be painting on. While looking, move both pieces until all four sides of your canvas line up approximately with the four sides of the opening in the viewfinder. The viewfinder will now have the same proportions as your canvas or panel.*

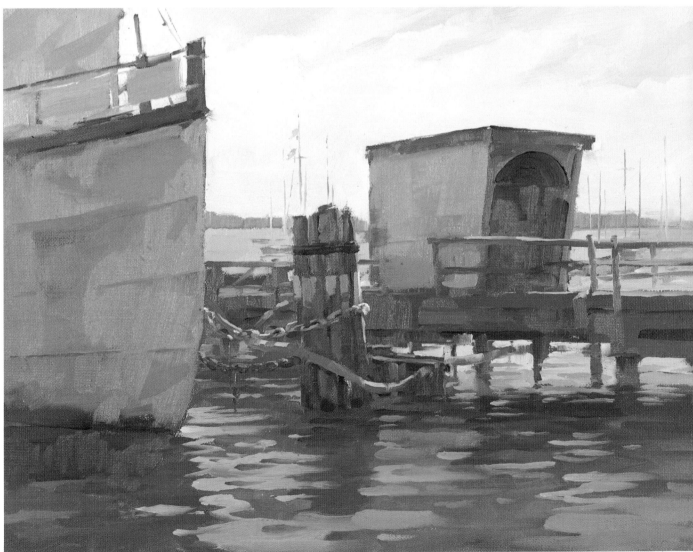

Dock with Pilings, 1984. OIL, 12″ × 16″ (30.5 × 40.6 cm)

Sketching Is an Excellent Way of Learning to See a Subject

Since there are many interesting subjects that we come across every day, learning to see them and recognizing whether or not they would make a good painting requires some understanding and study of the world around us. Sketching directly from nature, and making life drawings in the case of human subjects, gives the painter an excellent method of studying and learning to see. All the solid principles of good picture-making are found in life. They are always there for the painter's use. It is only necessary that you know what to look for and how to recognize a good subject when you see one.

Sketching is a way to quickly record what you see and to note any ideas you may have. When sketching, you should not become involved in details. Every subject has certain larger and more important parts that make it appear to us the way it does. The dark and light tonal arrangement as well as the color harmony and balance are basic things that every picture is composed of. These should be put down accurately. It is not enough to be able to pick out and recognize the many individual details or forms; it is necessary to see how all these separate things are held together, are part of some larger mass or unit. In order to see something clearly so that you will know whether or not it will make an interesting subject, you must first be able to see it as a large, cohesive unit.

The material used for sketching can be elaborate or very simple. If you want to work in color, some painting equipment is necessary, or some other form of colors such as pastels may be used. Seeing that you never know when an interesting subject will come your way, it is a good idea to always be prepared. Some drawing pencils and a small sketchpad are adequate for this purpose.

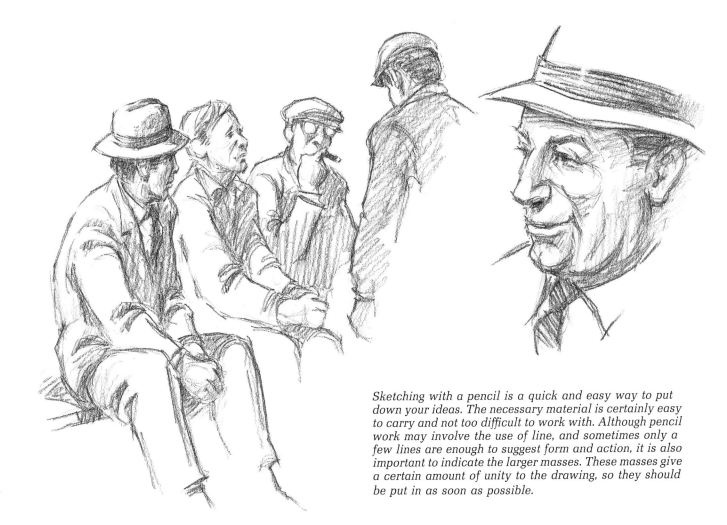

Sketching with a pencil is a quick and easy way to put down your ideas. The necessary material is certainly easy to carry and not too difficult to work with. Although pencil work may involve the use of line, and sometimes only a few lines are enough to suggest form and action, it is also important to indicate the larger masses. These masses give a certain amount of unity to the drawing, so they should be put in as soon as possible.

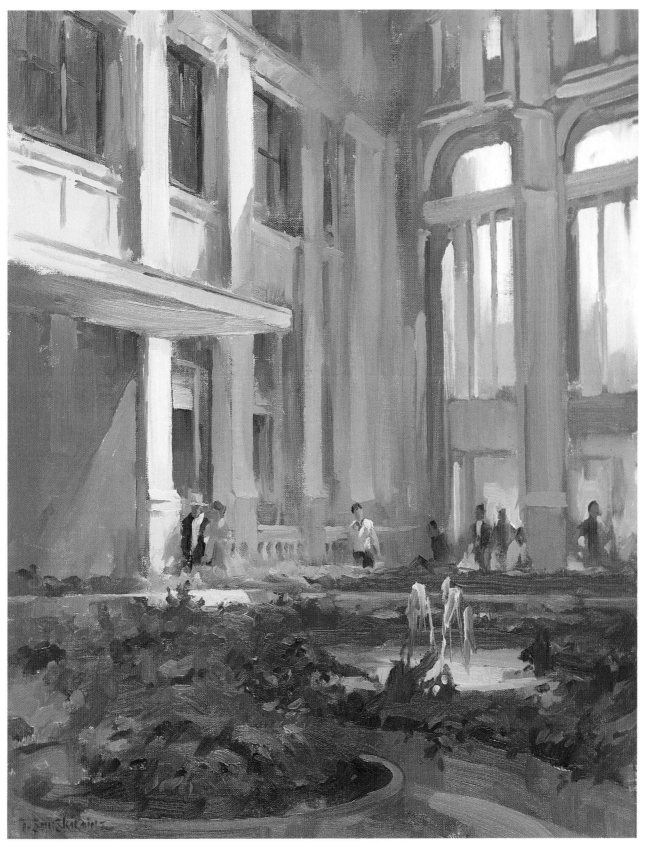

Courtyard and Garden, 1984. Oil, 14″ × 18″ (35.6 × 45.2 cm)

Chapter Two
THE EFFECT OF LIGHT ON THE ORDINARY

Light enables us to see and recognize form and shape. It also strongly affects the color of things. A tree and fence seen in the morning light may scarcely catch our attention. The scene viewed later in the day, however, may appear very eye-catching because of the different light effects. The newsstand where we buy the morning paper, the little grocery store around the corner, and even the postman delivering our mail—these everyday subjects can be transformed into something out of the ordinary if the effect of light is just right.

The way in which light illuminates or strikes a subject is what gives it its appearance, creating dark and light tonal areas that the artist can reduce to simple masses of dark and light. When we look at something, we respond to what we see in part because of the balances between these different tonal areas.

EVERYTHING APPEARS TO US THE WAY IT DOES BECAUSE OF THE EFFECT OF LIGHT.

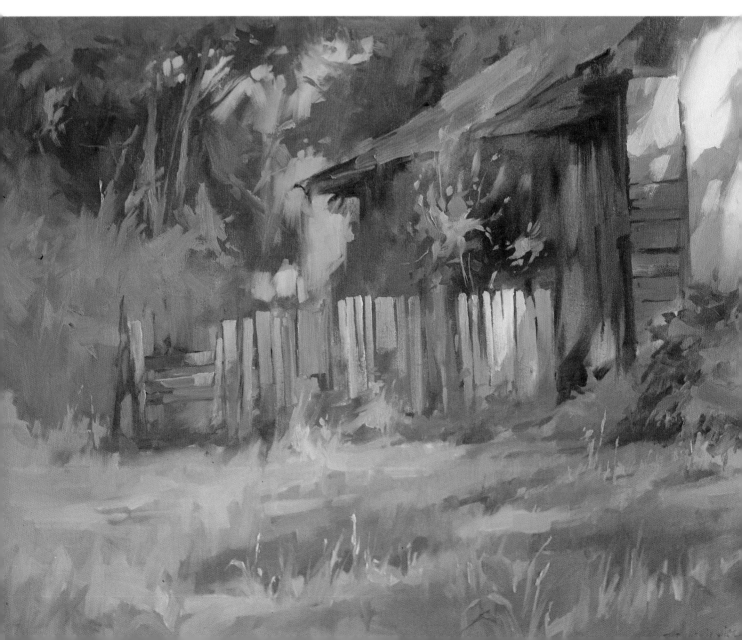

Light Is Necessary in Order to See and Recognize Form

Form with outline only.

Basic dark tone from one light direction.

One of the most interesting things about the effect of light is its ability to make a given subject appear more or less interesting at different times of the day or night. This is because of the way a form reflects light back to the viewer. Form either reflects or blocks out the light, thereby producing a certain arrangement of light and dark.

As the direction of the light source changes, the form takes on a different appearance, with a new arrangement of light and dark, because different surfaces now catch the light and others go into shadow. Using one light source creates shadow areas that combine to make tonal shapes. These larger tonal shapes not only help show the form but they also pull the different parts of the composition together with a common dark or light mass.

Form totally covered with dark tone.

Different directions of light create different tonal shapes by combining dark shadow areas.

Fence and Trees, 1984.
Oil, 24″ × 30″ (61.0 × 76.2 cm)

As shown in the painting at left, light as it illuminates or strikes a subject creates an arrangement of dark and light tonal areas. All the different tonal areas that light makes possible can be divided into two simple divisions of dark and light by combining or grouping similar tonal areas together. These simplified dark and light tonal areas, or masses, help hold the picture together and are an important part of the compositional structure of a painting, as can be seen in the structural diagram at right.

The Direction or Source of Light Is Important

When looking at a subject, it is important to recognize the direction or source of light and what kind of light it is. The direction of light determines the tonal appearance, and the temperature or main color of light affects the way the subject's color appears to us. The strength or weakness of the light is also important.

Note too that there should be only one main light source. This enables you to keep some control over the way light strikes the different surfaces of the subject's form. You can make the same form darker or lighter by changing the direction of the light, so you should try to understand the important possible effects of the different light directions.

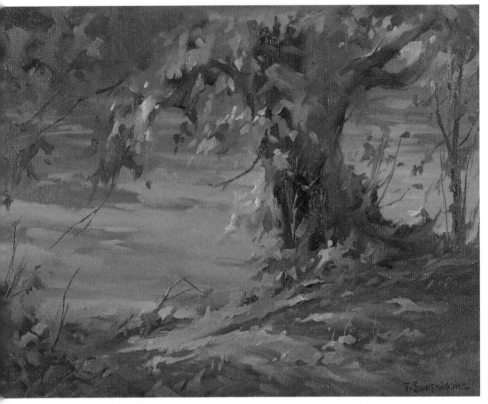

The strong light of the sun coming somewhat from the back gives this subject a feeling of solidity. Large, dark masses are created, and the strength of the light vividly brings out details. Notice how the lighter mass of the foreground in the sunlight connects with some of the lighter mass of water in the background.

Old Tree by the River, 1984. OIL, 16″ × 20″ (40.6 × 50.8 cm)

THE DIFFERENT LIGHT DIRECTIONS CAN BE PLACED IN FOUR SEPARATE GROUPS

1. FRONT LIGHT. There is not much dark here, but the little there is balances the larger areas of light. These larger light areas produce a bright and airy appearance. Front light can give interesting patterns or designs of color, although it can appear somewhat flat in certain arrangements. It can also provide a strong feeling of unity because all the surfaces have the same color temperature.

2. SIDE LIGHT. Here we have larger areas of dark with many places of strong contrast between the dark and light areas. This type of lighting can be definitely dramatic; rich texture and strong color contrast provide an ever-present feeling of vitality. Also, side lighting makes for a strong unity in your composition because the large masses of dark in the shadow areas hold together many individual forms.

3. BACK LIGHT. The major effect of back light is mostly dark areas with only a little light. Like side lighting, there is a strong dramatic appearance but in a much more solid manner. A very powerful unified effect results with back light because most of the individual forms are in the same dark shadow mass. Back lighting gives a silhouette-type of appearance to the subject.

4. OVERHEAD LIGHT. This type of light, although somewhat similar to side lighting, has its own qualities and can prove very useful to the artist. Overhead light develops the form strongly and evenly, with the vertical surfaces darker and the horizontal surfaces lighter. The overhead type of lighting effect is best seen on cloudy and overcast days, with the main light diffused and filtering downward. This type of lighting can be dramatic, or it can have a tranquil effect.

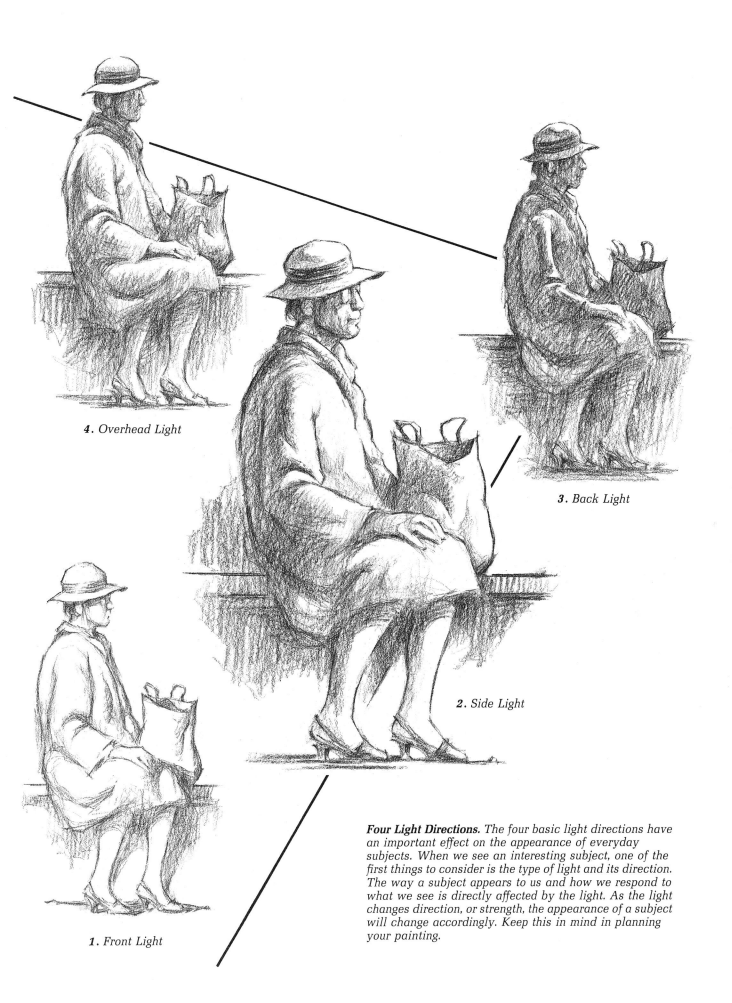

4. *Overhead Light*

3. *Back Light*

2. *Side Light*

1. *Front Light*

Four Light Directions. *The four basic light directions have an important effect on the appearance of everyday subjects. When we see an interesting subject, one of the first things to consider is the type of light and its direction. The way a subject appears to us and how we respond to what we see is directly affected by the light. As the light changes direction, or strength, the appearance of a subject will change accordingly. Keep this in mind in planning your painting.*

How the Effect of Light Can Simplify Form

When trying to simplify form, consider the outer shape, or silhouette. This will help you think about the general placement of the form. As you look at this shape, other divisions of dark and light will emerge until you can see enough of it to recognize who and what it is.

Every full tonal drawing or painting has its beginnings in a simplified dark and light tonal arrangement. A subject that may seem to be too complex can be simplified by pulling the darker forms together into simple masses. This will give the subject more interest and provide a feeling of visual unity.

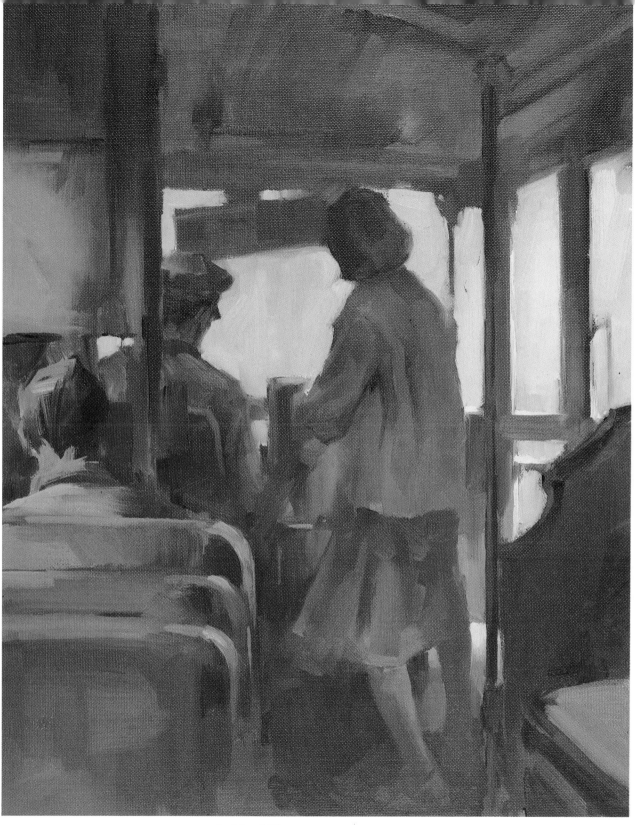

Inside of Bus, 1984. OIL, 16″ × 20″ (40.6 × 50.8 cm)

There are many interesting everyday subjects that we come across in our daily routine. An ordinary subject, like people riding in a bus, may at first seem not exceptionally interesting and perhaps even a little too complex. However, if you look closely at this painting you can see how dark and light masses were used to simplify the form and give more unity to this subject. The more complex forms of the figures and of the bus interior were simplified into a darker mass of tone. The smaller light areas outside were kept flatter and more simple to provide contrast to the detail that appears inside the bus. Edges are an important part of this composition. Since edges are boundaries between the dark and light areas, they needed some variety to keep the contrasty tonal arrangement from looking too cut-out and flat.

Natural Daylight and Artificial Light

Natural daylight and artificial light are the two primary kinds of light. The basic difference between them is that natural daylight is always changing whereas artificial light is, as a rule, much more steady.

Natural daylight includes the different lighting effects of sunny or cloudy and overcast days. Even a misty and foggy type of day has a definite daylight effect. Although moonlight is a nighttime type of light, it is a natural light and should be included in this group.

Artificial light occurs with the lighting of an interior—the inside of a room, store, restaurant, or subway train, for example. It can also be used in exterior night scenes where the main light originates from street lamps or store windows.

We have very little control over natural daylight, especially outside, although an interior subject lighted by daylight can be somewhat controlled with window shades or blinds. When the sun changes position in the sky, even on a cloudy day, there is a change in the light. During a sunny day, with the changing patterns of sunlight and shadow, this change is very noticeable. But even during an overcast day, one can still notice a change between morning and midday. Moonlight at night is also constantly changing as the moon progresses across the sky. The artist has only to be aware of these effects when they occur to be able to use them.

The great advantage of artificial light is that it affords us the most control. This is true whether the light is in an interior or an exterior scene at night. Seeing that the direction or source of light has many different effects on the appearance of the subject, it is easy to see why artificial light sources can be of such great benefit to artists. Just by turning off some lights and turning on others, a major change can be created in an ordinary room.

The Bicycle Man, 1984. OIL, 22″ × 28″ (55.9 × 71.1 cm)

In this painting, the window shades are partly closed so that the main light—sunlight coming through the window—is reduced a little in order to keep it in a more restricted area around the central figure of the man. The remainder of the room is darker but still has enough light in it so that you can recognize the different forms.

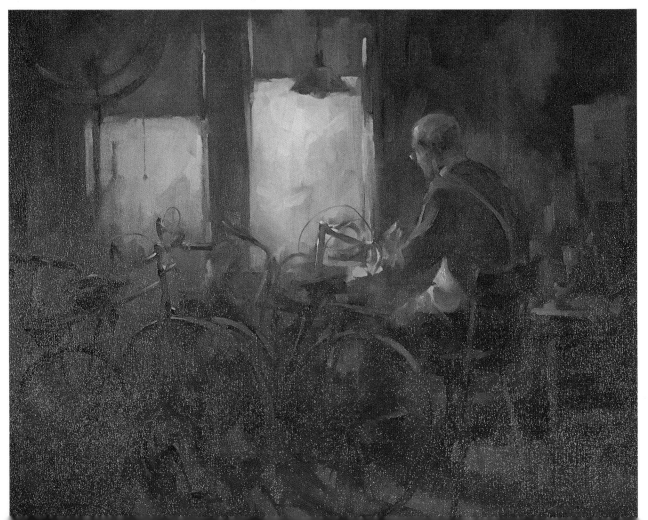

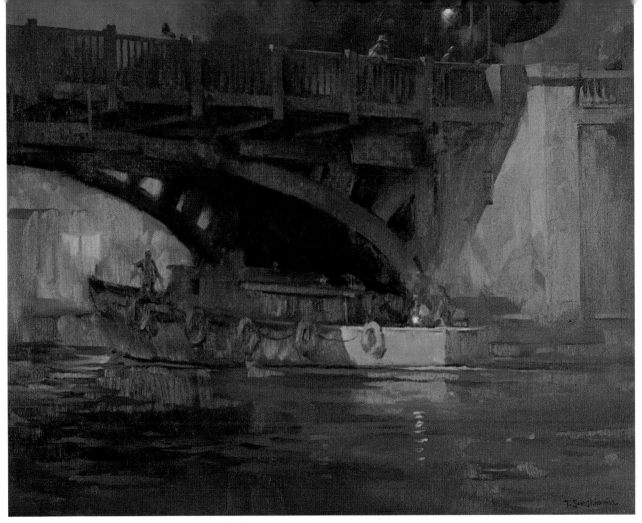

Night Passage, 1983. OIL, 24″ × 30″ (61.0 × 76.2 cm)

Sometimes it is possible to combine moonlight illumination with artificial light, as we see in this painting of a boat passing under a bridge out of the moonlight and into the shadow. Here, the effect of moonlight creates the larger forms of the subject, such as the bridge, wall, water, and boat. The artificial street and building lights add interest and give some vitality to the picture's color harmony.

HOW NIGHT AFFECTS THE LIGHT

Whether the outside light at night is from a natural source, such as the moon, or from street lights and building illumination, the appearance of a nighttime subject is very different from the same subject seen in daylight.

A nighttime subject does not have the even distribution of the light throughout the whole subject that can be seen in a daylight subject. At night, although there may be enough light to see the subject, the shadow and other dark areas always appear very black and dark. (During daylight, shadow areas receive a certain amount of incidental light, thus always showing some form.)

Another noticeable difference between natural daylight and nighttime illumination outside is found in color temperature. Natural daylight, with its sameness of color temperature, helps give unity to the whole subject. Although moonlight creates a certain

amount of unity through the sameness of its cool light, there are other forms of street and building lighting at night that have a variety of color temperatures. Some control is needed then in avoiding confusion in the over-all effect and also in keeping some unity in the painting. Emphasizing one main light and temperature and subduing the other lights is a solution to this problem.

With moonlight, the same cool temperature of the light helps unify the whole subject to give unity to the painting. At the same time, the deep, dark shadow areas also help contribute to the unified effect. Compared with sunlight, moonlight illumination is weak, with extremely dark and flat shadow areas. Therefore, it is necessary to paint the tone values in a moonlight picture in a lighter range in order to distinguish individual forms more clearly and to give depth to the shadow areas.

IMPROVING THE LIGHT EFFECT

Sometimes when you see an interesting subject that would make a good painting, there seems to be something lacking in its appearance. Sometimes the tonal structure of a subject is not as interesting as it could be. In this case, it is possible to reverse or change some of the tonal areas while leaving other areas as they are. By changing selected areas, the artist can improve the effect of existing light.

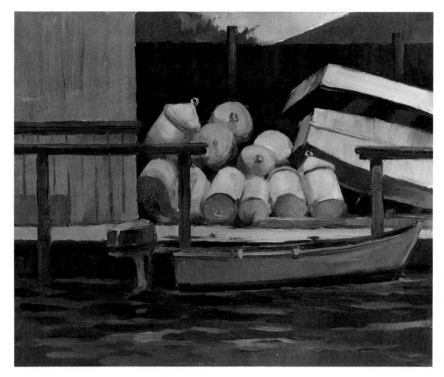

The cluster of lighter-toned bouys near the center, with the dark fence behind, gives this composition a strong concentration of light near the center. The foreground of water seems to have too uniform a tone. Although the general effect of light is alright, something seems to be missing in the arrangement.

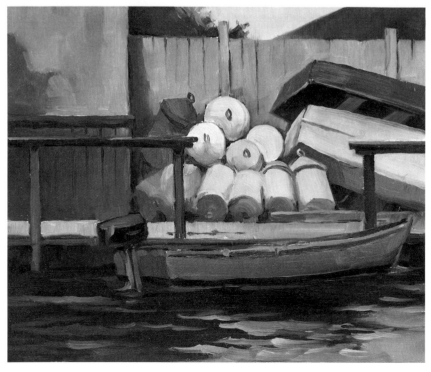

It is not always necessary to change the source or direction of the light to change the appearance of the composition. What was a dark-toned area can become a light-toned area. The direction of light and the arrangement of the subject remain the same; only the tonal areas change. The bouys are still the main interest area, but now in an entirely different way.

26

Changing the Observing Position Will Affect the Way a Subject Appears

Another way to improve the way a given subject appears is to change the viewing position. Never be satisfied with your first viewing position. Move around a little and continually study the subject from different positions. Remember to use your viewfinder to isolate your subject and also squint when you look in order to see the larger units of dark and light more clearly. Only by observing the subject from different positions will you be able to compare and choose the best view.

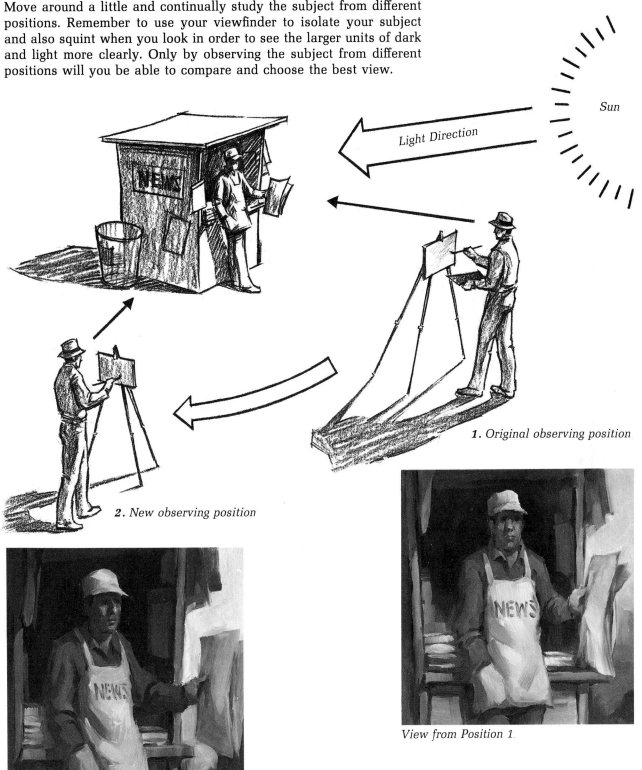

Sun

Light Direction

1. Original observing position

2. New observing position

View from Position 1

View from Position 2

Different Light Conditions Can Change the Appearance of Everyday Subjects

These two illustrations show how changing the light can alter the appearance of a subject. As the late-afternoon sun drops lower in the sky, larger shadow areas appear, creating a new and different arrangement of dark and light masses. Along with the change of tonal masses there is a change in edges. The way we see a subject depends on its tonal balances. A subject can change dramatically with the changing light, and what may not appear too interesting at one time of day may, at a different time and in a different light, become much more attractive.

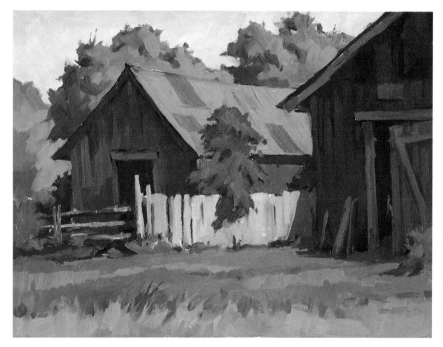

Midday light on a sunny day usually provides large areas of light and many areas of color in a strong design. You can get a light, airy effect in the painting by keeping the darker shadow areas smaller. This type of light can have a tranquil effect or a dramatic appearance, depending on what type of contrast you develop between the light and dark areas.

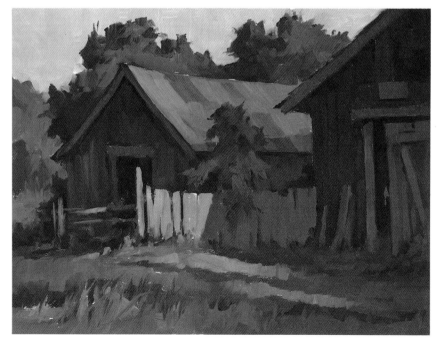

Late-afternoon light on a sunny day has a very strong dramatic appearance. The long shadows of afternoon fill up the painting and give it a darker effect. However, the smaller light areas are quite strong and definitely contribute to a feeling of vitality. A richness of color will show in the shadow areas, giving them much depth. Color will generally be more intense than with midday light, with a somewhat warmer effect in the lights because of the lower sun.

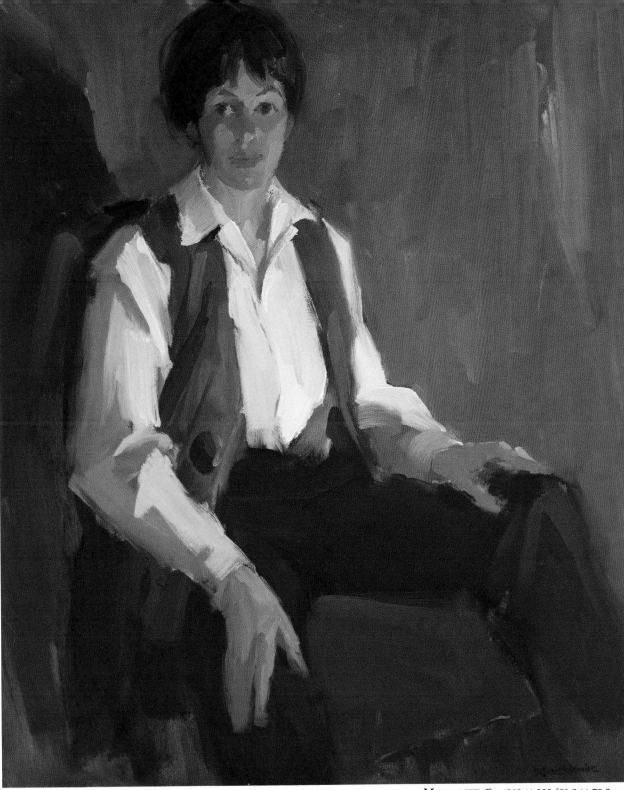

CHANGING THE LIGHT SOURCE

Although nature provides much in the way of interesting light effects with both natural and artificial light sources, there are occasions when a subject can be made more attractive by creating new light effects. This may involve constructing an entirely new lighting source or taking an existing one and improving on it.

Artificial light is easier to control than natural daylight. In order to create new light effects, we have only to turn some lights on or off, or reposition them to get entirely different results. In the painting below,

the light was placed in a position lower than the subject's head. This caused an arrangement of dark and light throughout the figure entirely different from that which an overhead light would have given. It was relatively easy to find this light position by moving the light around and comparing the different light effects before making the final selection.

If the existing light effect is not right but the subject is good, do not hesitate to try to change the light source to get the best possible light effect for your subject.

The Influence of Weather on Light

Among the factors that influence the effect of light in natural daylight is weather. Places that have variety in their weather conditions offer frequent changes in light effects. However, even in an area of stable weather there is a continuous change in the light during the day.

When an everyday subject is seen in strong sunlight, its arrangement of darks and lights is relatively easy to see. Any slight change in the position of the sun immediately affects the appearance of what we are looking at. A cloudy, overcast day, with softer light and less contrast, produces an entirely different type of light effect, with softer edges and much less contrast between the different tonal areas. The middle range of tones usually dominates this type of lighting effect. Although the strong contrast of bright

sunlight is not present, there is nevertheless a complete range of tone from dark to light. Only now the extremes of the dark and light tones are unified somewhat through the use of the middle tones.

During severe weather conditions, such as in rain, snow, or fog, there is a more noticeable change in the appearance of things, especially as they recede into the background. The much denser atmosphere not only greatly diffuses the natural daylight but it also makes all forms, as they recede into the distance, diminish into simple and obscure shapes. In this type of lighting, the darker tonal areas become lighter as they become part of the background.

Think of light as the shaper of form. As the sculptor shapes and builds form out of a lump of clay, light, as it strikes a subject illuminates and defines its form.

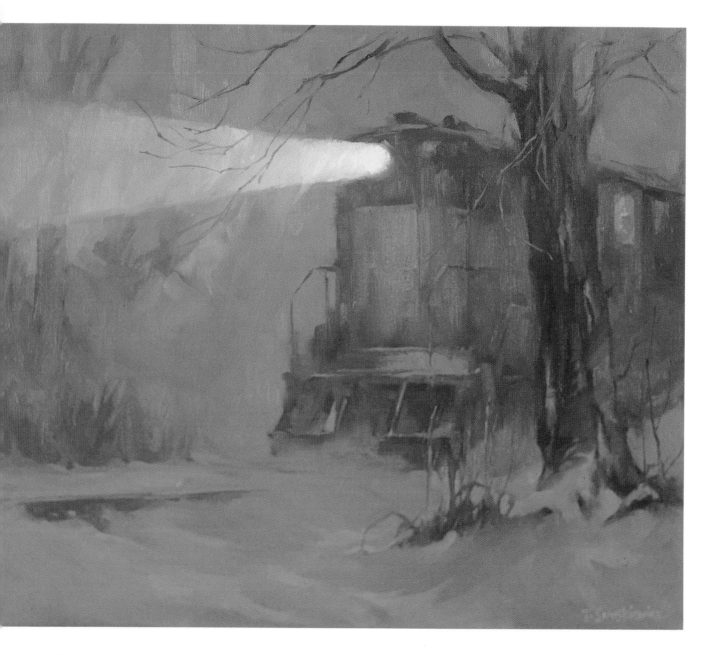

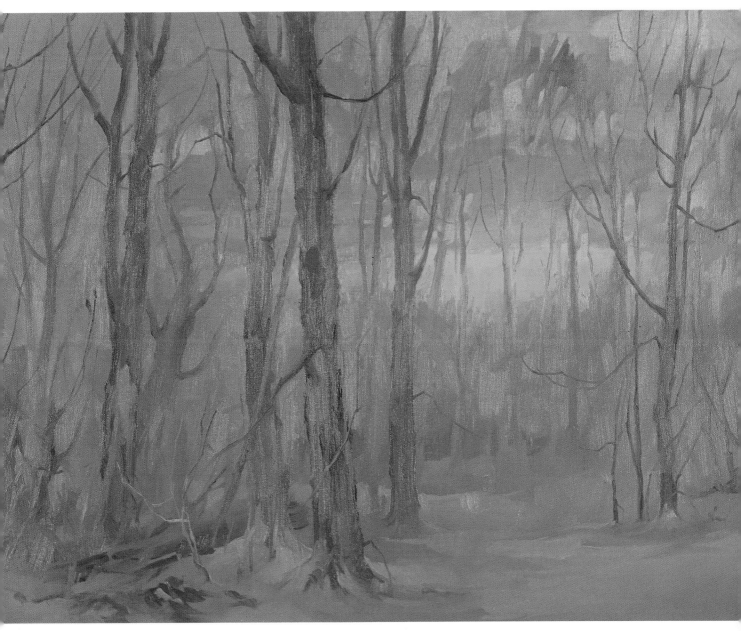

Winter Sunset, 1984. OIL, 18″ × 24″ (45.2 × 61.0 cm)

Certain times of the year, and of the day, have their own particular light effects. In this painting the haziness of a late-winter afternoon shows against the setting sun. The warm glow of the western sky is spread throughout the woods because of the heavy atmospheric conditions there. As forms recede into the background they rapidly diminish in strength.

Train in Snow, 1984. OIL, 20″ × 24″ (50.8 × 61.0 cm)

The snowfall that inspired this painting began during the afternoon. By evening, when I observed the train coming through the falling snow, it had turned into a small blizzard. Note how the density of the falling snow diminishes and softens the forms in the background and elsewhere.

Chapter Three

USING DARK AND LIGHT TO EXPRESS YOUR FEELINGS

As seen in the previous chapter, the effect of light on a particular subject can cause it to appear to us in different ways because of changing tonal arrangements. This dark and light tonal arrangement is so influential that it requires its own in-depth study.

The first thing that impresses us about what we see is probably this arrangement and balance of the different tonal areas of a subject. Even color, with its strong influence on the final effect of the picture, is dependent on a good tonal foundation. How we put these different tonal areas together depends not only on the actual appearance of the subject but also on how we percieve and are able to use the balances between them. How we see the tonal balance is directly affected by our feelings and our emotional response to a particular subject. Because of this, the artist must learn to see and to develop his or her individual sense of good selection and judgment when it comes to balancing the tonal masses of a pictorial composition.

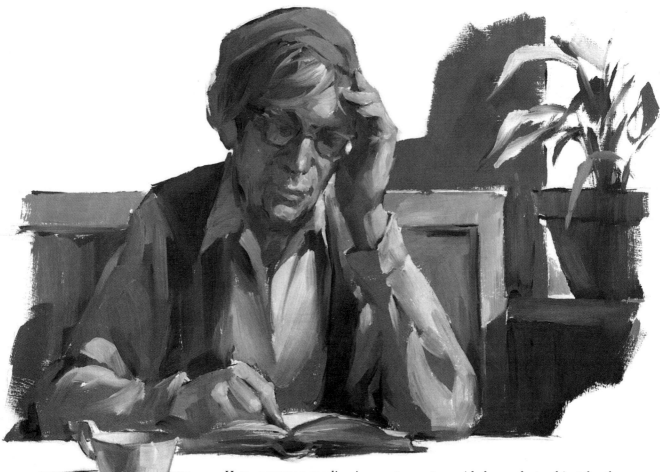

Here, a woman reading in a restaurant provided a perfect subject for the illustration of the power of dark and light tonal masses in a picture. The window light to her side provides an over-all tonal range, throwing those areas not directly hit by the light into an area of darker tones, all grouped together. The cast shadows help identify the source, or direction, of the light. The softened and lost edges and the use of line direction help focus attention on the subject's emotional content and contribute to the effect of the picture.

THE TONE VALUE SCALE

Black is the darkest tone and white is the lightest, with a complete range of tones in between. This full range, from black through the graduated grays to white, is called the *tone value scale* and can be divided into five basic groups: black, dark, middle, light, and white. In order for us to be able to see the full form or an in-depth appearance of a given object, at least the dark, middle, and light tones must be present. The addition of the black and white tones will add more dimension to the form's appearance and give it a stronger effect. The tone value scale provides all the tones necessary to paint a subject in any lighting condition. Some subjects require the full range; for others a narrow range will suffice.

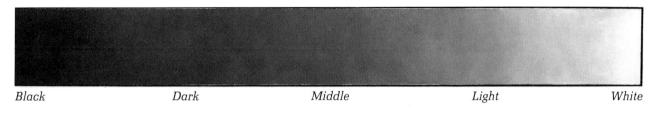

Black *Dark* *Middle* *Light* *White*

THREE MAIN DIVISIONS OF TONE

Light, as it strikes a subject from one main direction, brings out that subject's full form. The different surfaces of a subject either receive light or turn away from light into shadow. There are three main divisions of tone—dark, middle, and light—that these different surfaces reflect back to the viewer. Every form, in order for it to be fully seen, must have these three divisions of tone. Sometimes the darker or lighter tones group themselves together into larger and more simple masses of tone, which gives a great deal of solidity to a painting.

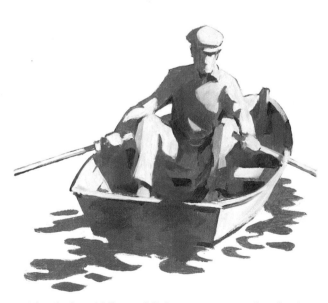

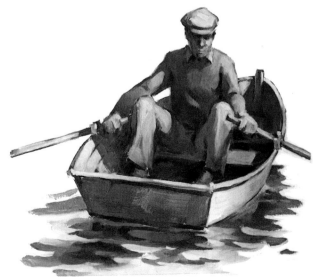

1. The dark, middle, and light tones are used to begin, or block in, the full form of this subject. The dark masses hold together the many different parts.

2. Here, the same dark mass arrangement is given a fuller range of tone with complete edge control, resulting in a more finished appearance.

The Enclosing Picture Rectangle and Its Importance

When you first look at something of interest, your eye takes in more than is necessary. That is, you are aware of the subject's surroundings as well as the subject itself. Developing a picture out of what is seen requires first that you establish some sort of picture border or enclosing rectangle. Using a viewfinder or framing device adjusted to the same proportion as the proposed picture will allow you to see the subject as it will appear in the finished picture. Composing a picture from your imagination also requires a bordered area in which to work.

Therefore, the first step in composing a picture is to establish the enclosing picture rectangle. The composition of any picture depends on the way the many individual parts of a subject are placed within this area. The line and tonal areas, as well as the individual colors and their areas, all balance against the enclosing borders of the picture. Anything that is placed in this enclosed space will react or be affected by other things already there or by the enclosing borders themselves.

Building a successful picture involves the use of good composition. Good composition is good selection and placement of the subject into the enclosing picture rectangle so that it is just as we see it or envision it.

This first view of the subject shows an arrangement of dark and light areas within the enclosing borders of the picture rectangle.

Showing more of the figure and less of the background creates a new arrangement of dark and light areas in the picture rectangle.

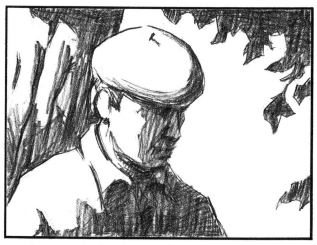

Emphasizing the head again changes the dark and light arrangement within the enclosing picture borders.

USING UNEQUAL SIZES AND DIVISIONS FOR GOOD BALANCE

What something is and how it is placed within the enclosing picture area affects the appearance of the picture. *Balance* refers to the relationships that exist between the many different parts of a picture. In the type of picture that we are concerned with, that is, a picture with the informal arrangement that usually appears in life, it is important to keep in mind an important principle of balance: the use of unequal sizes and divisions for proper picture balance is a basic idea in good picture-making. When things of equal size, shape, distance, or other appearance are placed together within an enclosed area in an equal manner they overbalance and cancel each other out. However, when some of them are different than others and they are placed together in an unequal but correct manner, the result is a balanced appearance with a feeling of vitality and interest.

Balance is created by contrast. There must be an opposite thing for something to balance against. If everything is the same, then there is nothing to compare with. You can create contrast by using different sizes, balancing something larger against something smaller, or by using tonal masses in ways that set darks and lights up in compositionally interesting ways.

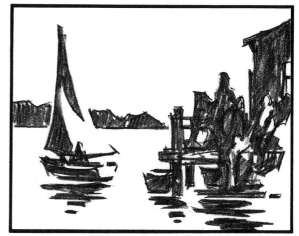

A large mass balanced by a smaller mass.

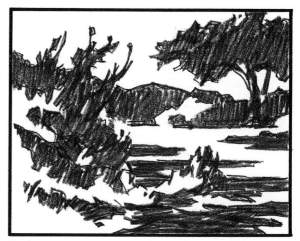

Dark masses occupying a larger-size area.

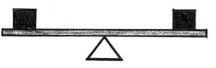

Equal sizes and weights balanced on a lever with the fulcrum in the center gives a stable appearance.

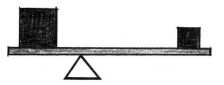

Unequal sizes and weights balanced on a lever with the fulcrum well off-center gives a more dynamic appearance.

Some examples of incorrect tonal balance and arrangement.

Main mass centered and equally spaced on sides.

Large dark mass cutting picture exactly in half vertically.

Small dark masses too equal in size and separation.

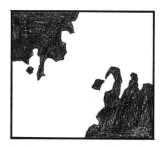

Dark masses equal in size and placed in diagonally opposite corners.

Tonal Distribution as a Basic Beginning

Of the many things that go into the making of a good painting, the subject's dark and light tonal distribution has the first strong influence on the picture's development. Although an interesting subject may appear somewhat complex at first, it is possible to reduce it to a simple arrangement of dark and light tones. The way these basic tones are arranged in the enclosing picture area will strongly affect the painting's appearance.

When simple dark and light tones of different sizes and shapes are placed together in the picture, they react with each other and the enclosing borders of the picture. Certain arrangements take place that give a particular feeling of balance, or other alignments may occur that lead the eye a certain way. Our individual sense of where and how these differ-ent tonal shapes should be placed depends on our intuition, good judgment, and the general feelings we may have for a particular subject. Our sense of balance can be further developed through practice with different types of tonal constructions and through direct observation.

We have only to look at nature and at the world around us to see a variety of arrangements and balances that would make wonderful tonal studies. Tonal studies can be done outdoors, on the spot, or indoors with a still-life setup. For indoor work, all you need is a portable light that can be moved into different positions. Make sure you use only one light source and try to keep away other incidental light. Be sure to squint when studying the dark and light tonal structure.

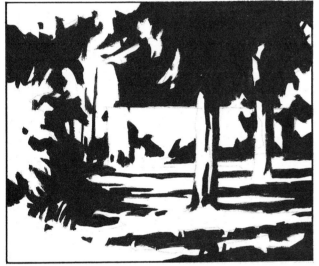

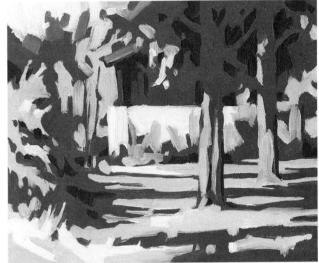

1. The first basic reduction of the subject into a simple arrangement of dark and light tones.

2. Using the middle range of tones helps develop the full form of the subject.

3. Further refinement of tone and edges completes the picture without losing the original tonal distribution.

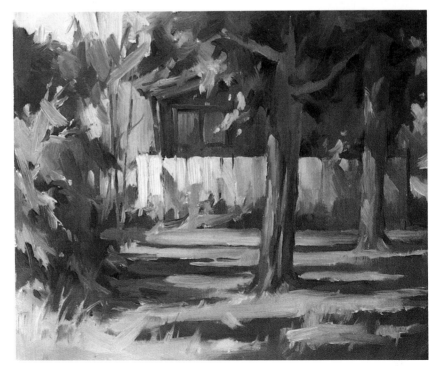

Using Middle Tone for Form and Unity

Although an underlying dark and light tonal structure gives strength to a composition, the use of the middle tones develops the full form of the subject. The subject's form, or combination of forms, can and often does influence the whole effect of what is seen. Although different forms can merge to become part of larger masses or shapes, some awareness of the individual forms is necessary in order to achieve a feeling of space or depth in a picture.

The middle tone also has considerable influence on the over-all effect or feeling of the painting. By forming a connection between the widely separated dark and light tones, the middle tones help hold the picture together.

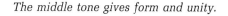

The middle tone gives form and unity.

Size of Tonal Area Gives Mood and Feeling

Tones may be distributed throughout the picture in a number of different ways. Will the picture be made of basically darker tones with smaller light tonal areas, or will it be predominantly a lighter-toned picture with smaller areas of darks for contrast? This relationship between the different tonal groups and the area size that they cover in the picture has a strong effect on its finished appearance.

Here are three tonal arrangements that can be used as a guide to developing certain effects in a picture:

An almost evenly distributed tonal arrangement with the dark, middle, and light tones occupying about the same size area can give stability of composition. It can show form in a strong and unified manner with vitality and interest if the light source is just right.

An uneven tonal distribution with the darker tones dominating the picture can give a somewhat somber effect with a feeling of closeness of space throughout. A good arrangement for an interior, a night scene, or perhaps a subject of a profound nature.

An uneven tonal distribution with the lighter tones dominating the picture can give an airy and cheerful effect with an impression of much light and space.

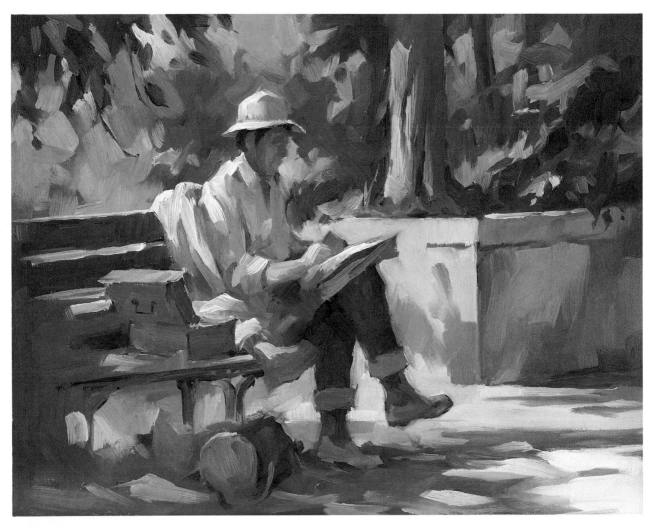

This picture is dominated by the middle range of tones. The arrangement of the seated figure and the larger areas of middle and dark tones throughout the picture give it a restful and tranquil effect. The main light source is from behind the figure and some of the edges between tonal areas are lost and indistinguishable, resulting in an interesting and unified composition. Notice the uneven distribution of the lighter areas.

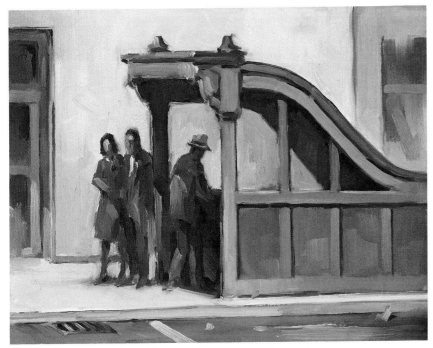

The larger areas of light and middle tones give this painting an open, outdoor effect. This contrasts with the smaller dark area of the subway entrance, to convey the feeling of going from the outdoor light into the enclosed and dark underground subway.

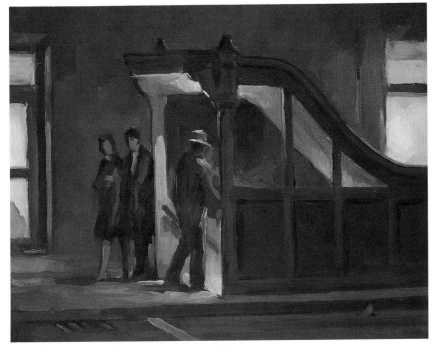

The same picture is now developed as a night scene by using larger areas of dark tones with much smaller light tones. This gives the picture an over-all heavy, enclosed feeling. The much lighter entranceway now gives the feeling of being a refuge from the dark and enclosing night.

Painting a subject to express our feelings about what we see depends on our using all our abilities in pictorial arrangement. As with basic tonal distribution, the correct use of tonal-area size gives us more influence and control in expressing what we see.

When going indoors or into a heavily shaded area after being out in the open on a bright, sunny day, our perception is certainly influenced by the abrupt change. Any change in the tonal arrangement of our environment or surroundings will affect our emotional response to it. This also holds true of the tonal arrangement of a picture: any change in the way the many different tones are placed will cause a change in the way a picture will affect the viewer. Therefore favoring one tonal group over another, or arranging them in a particular manner, can give us some control in showing the pictorial effect desired.

Tonal Exercises to Help Distribution

In order to develop your sense of tonal balance and arrangement, it is necessary to continually practice with different tonal arrangement problems. Tonal exercises provide an excellent method for improving your effective use of tone.

Any exercise that concerns itself with pictorial arrangement must first begin with the picture rectangle. When doing the tonal exercises that follow, be sure to always draw this picture rectangle at the very beginning. Remember that any tone that is placed within this area will create a balance with other tones already there or with tones yet to be placed.

1. Using white drawing paper and a medium-hard pencil, divide a rectangular area with a series of lightly drawn lines. Start at one side and draw lines that wander almost aimlessly over this enclosing space until they touch another side. Continue dividing the rectangle in this manner until it is well covered with many lines.

2. With black ink or soft black pencil begin to fill in some spaces between lines. Place these dark shapes in several locations, keeping them not too large and trying to create an interesting arrangement. Remember to use uneven sizes and spacing.

3. Now fill in other spaces, trying to achieve some sort of balance and connection between the first dark shapes and the successive ones. Work strictly in abstract shapes. Remember to have either the darker or lighter areas occupy a larger place. Fill in only the spaces between the lines, combining several interesting spaces into one larger dark mass when necessary. Repeat this exercise many times, using different tonal distributions and arrangements.

Have either the darks or lights occupy a larger area.

TONAL EXERCISES USING THE MIDDLE TONE

Since the middle tones contribute much to the development of a picture in showing form and giving unity, any tonal exercises you do should include working with these middle tones. For the first middle tone exercise shown here, you will need some heavyweight gray paper of a middle tonal value, black opaque watercolor, and white opaque watercolor. Cut a rectangular shape out of the gray paper and attach it to a lighter board before beginning this exercise. In these exercises select some subject or form, but also keep in mind the underlying abstract quality.

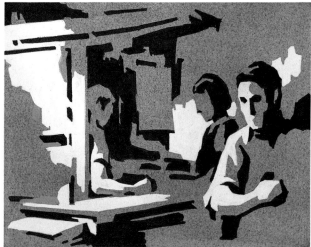

1. Use black opaque watercolor to paint in the major dark masses. Remember to try to group the darks together into larger masses whenever possible and avoid putting in detail.

2. Using white opaque watercolor, paint in some light masses of tone. Strive for a good balance between the size of dark and light areas. Notice how the light masses pull together or balance the darks.

Another method of doing tonal exercises is shown in these two illustrations. Begin the exercise by drawing a rectangular shape on white paper. With black opaque watercolor, paint in some dark tones, either keeping in mind some subject or thinking fully in abstract terms. Now paint in a middle tone using a gray mixture made of black

and white opaque watercolor. Notice how the middle tone gives unity to the first simple arrangement of dark shapes. This exercise can also be rendered with a very soft black pencil and white paper. Do all of these exercises repeatedly, using different tonal area size relationships and different dark and light tonal distributions.

Using the Tonal Key for the Best Effect

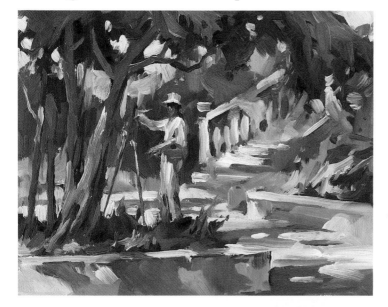

The tonal key, or range of tones, used in a painting has a considerable effect on its appearance. In this picture a full range of tones, from black to white, was used for maximum contrast and vitality, and in order to give the effect of a crisp, sunny day with strong shadows, they were arranged in a broken and contrasty pattern. You can use the full range of tones in many different subjects and to achieve a variety of effects, depending on what size areas are covered by the tones and how they are distributed throughout the picture.

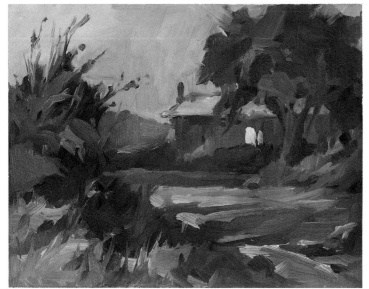

This night scene uses a more narrow range of tones. By restricting the tonal range to the dark and middle tones, a more quiet and tranquil effect has been achieved. This effect, of course, still depends on good tonal distribution. Many of the forms are grouped into dark masses and the tonal key is basically in the dark and middle range which helps give the picture its effect of a quiet night. The light in the distant window provides a contrast in tone to the darker tonal arrangement of the picture, reinforcing the nighttime effect.

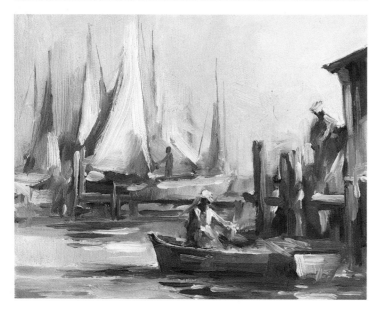

Here, a light and airy effect is achieved by again restricting the tonal range, but now toward the lighter side of the tonal value scale. The larger area of lighter tones plus the more narrow tonal key and the profusion of soft edges give the picture its hazy and sunny effect. This tonal key and distribution can produce a light and cheerful effect, as well as the calm and restful appearance shown here.

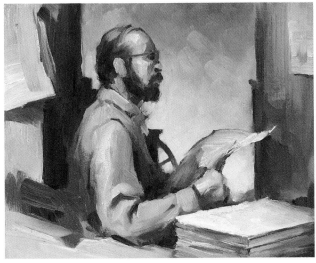

TONAL GRADATION FOR FORM AND UNITY

Using a variety of tones from the three basic tonal groups (dark, middle, and light) allows you to show the full form of any subject. Gradation of tone, or the gradual change from one tone to another, is what makes it possible to indicate form in a three-dimensional way. Any curving surface, for instance, whether it is a simple cylindrical shape found in architecture, or the human figure, uses gradation of tone to show its exact form.

Another use of tonal gradation is in the development of the complete picture instead of the individual subject forms. Through the use of this over-all gradation, any arrangement or distribution of forms, no matter how complex and busy looking, can be given a sense of unity, of cohesion. This tonal gradation can be used as a background, or in parts of the foreground, such as in water or in shadow areas. A gradual change of tone in a large individual form—a flat wall, for instance, or a standing figure where the head is in light and the legs are in shadow—can also help unify it and make it more interesting.

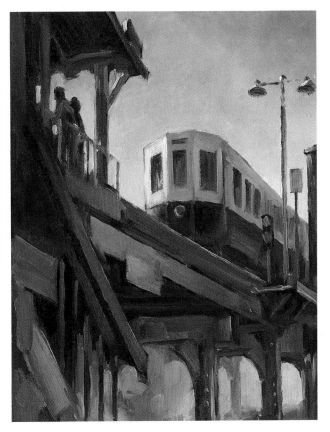

The tonal gradation here is found basically in the background. Tonal gradation is also used in the too-evenly shaped stack of paper in the lower foreground and the somewhat plain wall on the right to make them more interesting.

Here, the many abrupt changes in the direction of form and in shape are held together by gradation in tone. Gradation is also used at the bottom of the picture and along the sides of the station structure to help unify its different forms.

Tonal Interchange Helps Give Unity

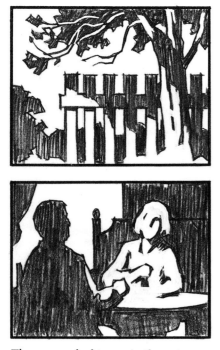

The reversal of tones in these two pictures helps give them unity with interest and vitality.

Tonal interchange is the reversal of tones in similarly shaped forms. When a picture is made of tonal areas that are too evenly arranged and divided, an introduction of some of the dark into the light and some of the light into the dark will help unify these separated areas. For instance, in the two pictures to the left, the top picture shows the use of tonal interchange in the reversal of tones in the tree and fence. Dark branches and a dark fence against a lighter sky, with lighter branches and a light fence against dark foliage, gives a certain amount of unity and interest to the picture. Unity is achieved in the lower picture through the reversal of tones in the two figures at the table.

Tonal interchange also gives a certain amount of interest and vitality to a composition. Sometimes just a small reversal of tones in a section of a picture is enough to give the picture much more interest. Observing and studying nature and scenes from life will reveal many examples of interest and unity created with tonal interchange. Just look for the reversal of tones in similarly shaped forms. Squinting and using a viewfinder will always help in observing these tonal relationships.

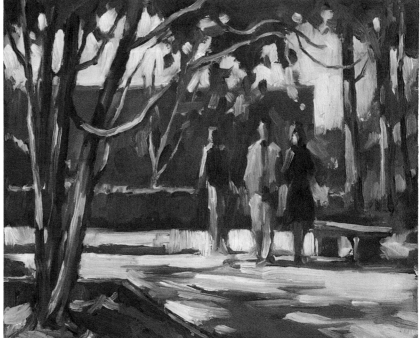

Tonal interchange can be found here in the trees and foliage, the figures in the background, and the sunlight and shadow pattern on the pavement. The more linear and contrasting arrangement of tones gives this outdoor picture an entirely different feeling than the picture of the bus interior to the right.

Reversing the tones in the bus driver and the passenger helps unify this composition. The simpler arrangement of tones gives this picture a quieter and more relaxed appearance than the outdoor composition to the left. However, this picture has a certain amount of interest and vitality because of the use of tonal interchange.

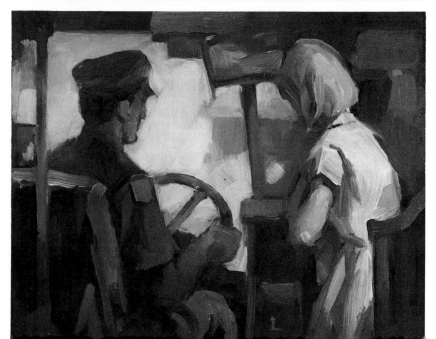

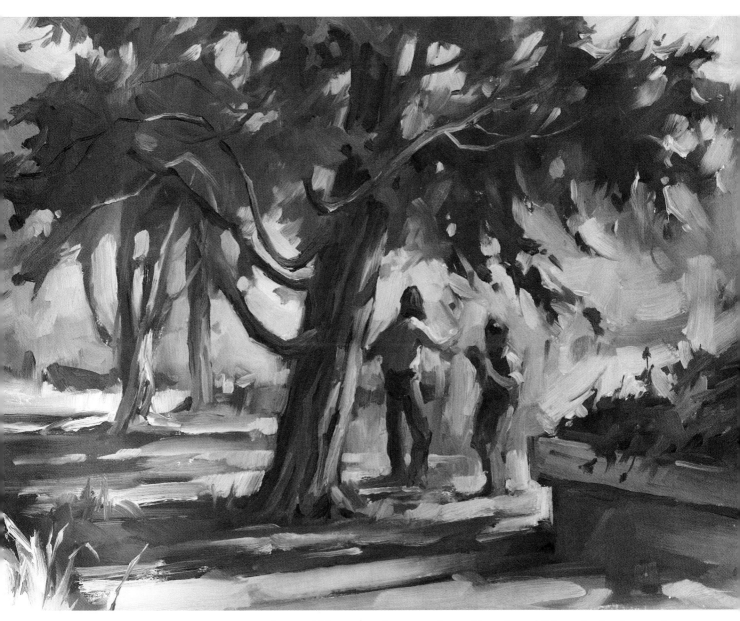

What could be more of an everyday subject than children playing in a park on a summer day? In order to achieve the feeling I wanted in this tonal painting, I used a well-distributed arrangement of darks and lights placed together in a somewhat broken manner to produce the effect of sunlight and shadow. Tonal gradation in the background behind the trees and figures helps unify the contrasty and abrupt shapes in front. Notice how the darker masses are grouped together, dominating the picture. Lost-and-found edges and the interchange of tones in the tree branches and foliage shapes give a certain amount of vitality to this composition.

There is another aspect of picture composition in this painting that we have not yet discussed. This is the influence of rhythm and line direction and how it affects the appearance of the picture. The recurrent and almost flowing directions of many of the dark shapes and the repetitive lines strongly contribute to the picture's rhythmic feeling. We will talk about these important qualities of picture composition in more detail in the next chapter.

Chapter Four
BUILDING THE PICTURE WITH LINE AND MASS

In order to develop an idea or a subject into a successful painting, you must use some type of controlled approach, such as building the picture with line and mass. Each subject or idea is made up of many elements that work together to impart a certain impression or feeling, something you react to. In this chapter we will see how line and mass can be used to simplify and interpret reality—how they can enable you to envision the completed picture from the very beginning and to build up your composition in a logical way.

LINE AND MASS ARE NECESSARY BASIC PARTS OF A PAINTING.

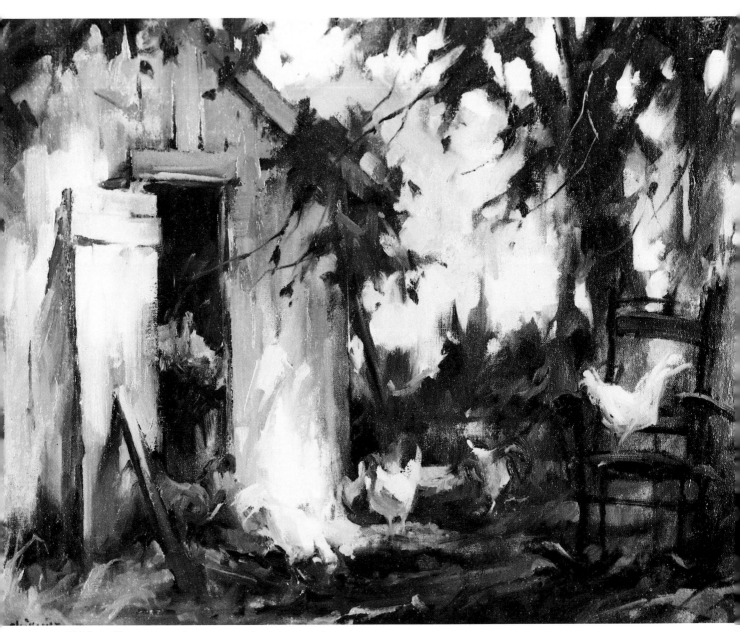

Chicken House, 1985. OIL, 18″ × 24″ (45.7 × 61.0 cm)

46

Every subject requires close individual study and thought to determine exactly how it will be handled. You can use a line indication to show the placement of the larger masses or you can simply lay in the mass areas without any indication of their boundaries and the individual forms contained within. Beginning a painting just with large mass indications requires that the artist think of the picture's tonal arrangement in a somewhat abstract way. Remember, as we discussed in the previous chapter, that a solid tonal structure provides the basic foundation upon which a picture is built.

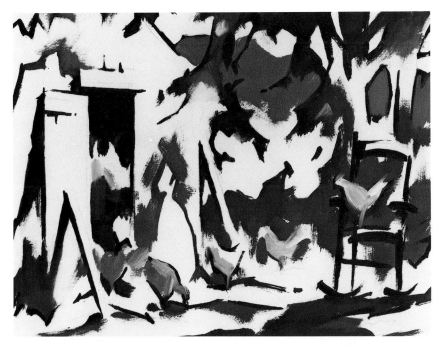

In the beginning stages of a painting, line is used to outline individual forms. Line is used also to indicate boundaries or limits of the masses of tone and color. The individual forms of the chickens, treetrunks, shed, and foliage are merely indicated. The main thing that line achieves at this time is to show us where we will place the larger masses of tone and color.

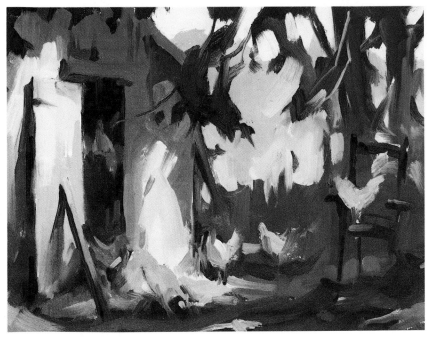

Here you can see the development of the larger masses of tone and color. A very important quality of mass is its cohesive effect. For instance, notice how much of the foliage pulls together with a similar mass structure and how the chickens lose their individual forms somewhat and become part of simpler mass areas.

47

Using Line in the Picture

When a beginner first attempts to draw, he or she most often outlines the individual forms. This is satisfactory for the beginning stages of developing drawing skills, but when an artist thinks of painting a complete picture, then the use of line must be able to cover a wider range of functions than mere outline. One of the qualities of line as used in a complete picture is its natural tendancy to give direction, or lead the viewer's eye in a controlled manner. Line can also determine how fast or slowly the viewer will follow that particular direction. The use of opposing lines can stop or impede the viewer's glance when necessary.

Another quality of line is that it provides boundaries between different tonal areas. In other words, the edges that separate different tonal areas are actually lines also. Naturally, some of these edges are harder and some are softer, depending on the individual forms shown. Sometimes the edge, or line, becomes totally lost as a result of the closeness of tonal and color areas that it divides. At other times, the division between some areas is so hard and distinctly shown that if it is placed in the picture just right, the viewer's glance will race rapidly along it.

There is yet another important quality of line as used in the composition of a picture, one which is not always taken advantage of by the artist. Every good picture depends on a certain amount of unity to hold it together, and line can have a great influence in contributing to this unity. First, the repetitive direction of a group of lines can unify different sections of a picture. Second, line, if it is strong enough, can enclose or connect several different forms throughout the picture. To achieve this effect, you may have to purposely reduce the strength of other lines.

To sum up, the use of line in a picture is not restricted to developing only individual forms but has an important larger role in constructing a well-balanced, effective, and complete picture.

Line provides boundaries to larger masses and at the same time it leads the viewer's glance throughout the picture.

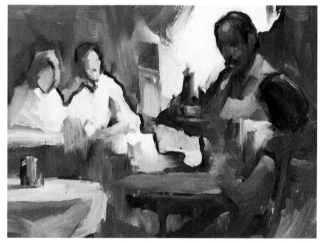

By connecting several different forms, line can give unity to the picture. To accomplish this, some other lines may have to be subdued.

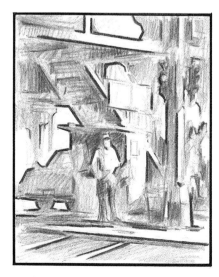

The News Vendor, 1985. Oɪʟ, 22″ × 28″ (55.9 × 71.1 cm)

The use of line here serves two basic purposes. First, it provides borders for some of the larger mass areas, which hold together separate parts of the picture such as the car in the background, the newsstand, and the underside of the elevated train station. Some of the lighter areas are also held together by their sameness of mass.

The second use of line here is to lead and give direction to the viewer's glance. Notice how some of the strong lines in the station structure help direct the eye around the picture. Sudden changes in line direction, or lines in opposition, help to slow down the viewer's glance in several places.

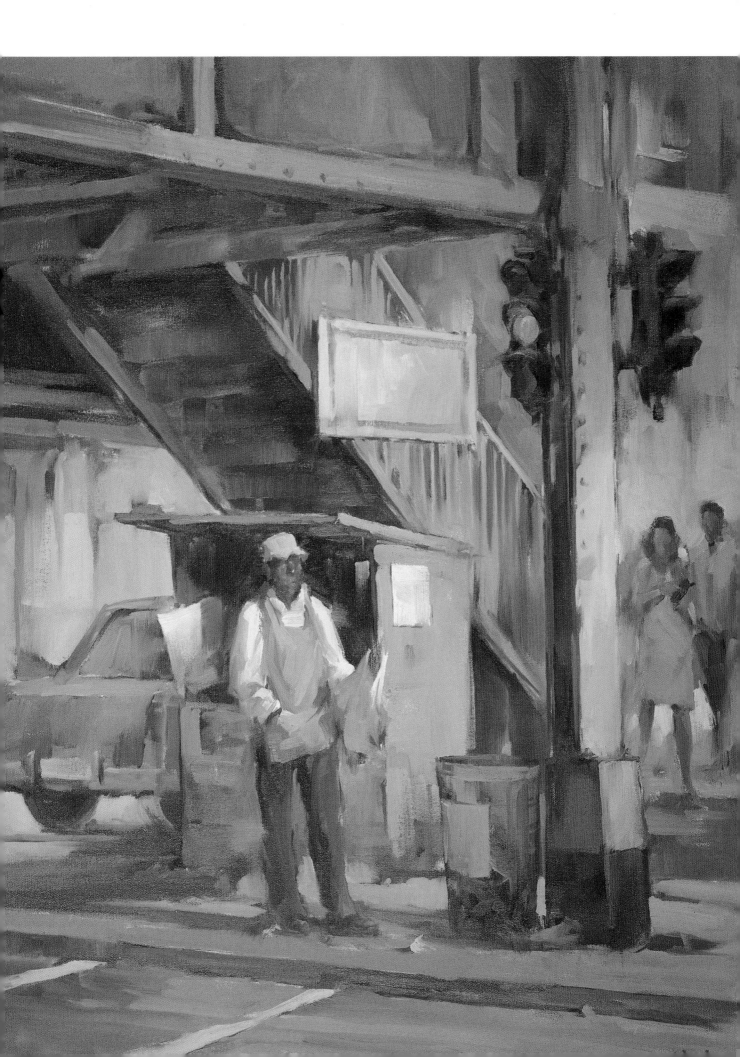

Using Mass in the Picture

A painting is made up of different areas of tone and color, some of which are very similar. Because certain individual parts of a picture share similar tones and colors, they will group themselves together into larger parts or masses, as we discussed in the previous chapter. So the first noticeable quality of mass in a painting is the way in which it pulls together many different parts of a picture into fewer and stronger units. This reduction of complex forms and individual parts into fewer and stronger units that share common areas of tone gives a picture unity. Unity not only makes for a much stronger picture but it also makes possible a more effective and clearer presentation of the artist's ideas.

Another important quality of mass is that it makes it easier to begin to develop an idea or subject. Some potentially good subjects are made up of many complex or different parts. Using mass will enable you to exercise some control over the effective arrangement of the subject. It will help you give unity to the picture and avoid the confusion of too many things competing for attention.

**USING MASS GIVES UNITY AND IS
A SOLID METHOD OF PAINTING.**

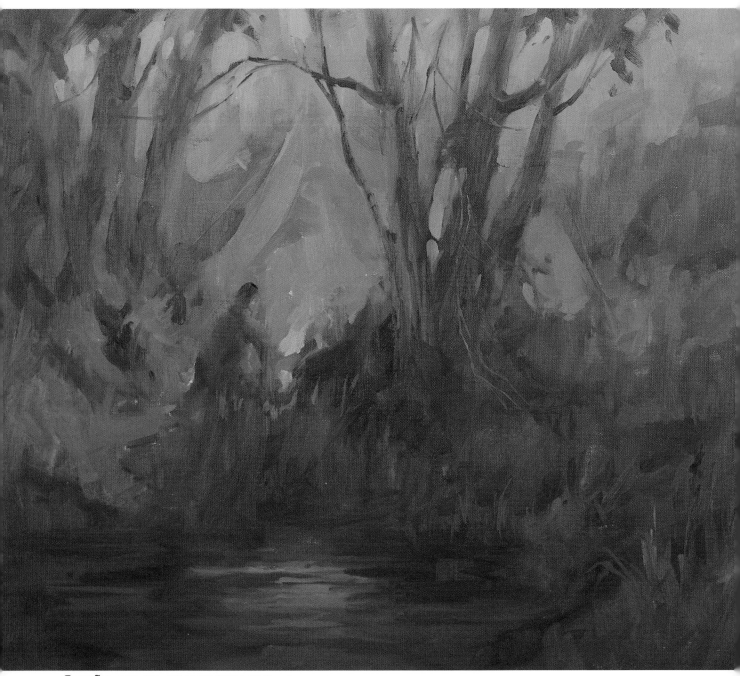

Campfire, 1984. OIL, 20″ × 24″ (50.8 × 61.0 cm)

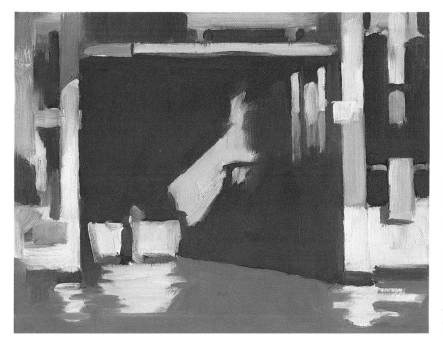

1. In the beginning of this painting, the larger masses only were blocked in with basic tones and families of color in an almost abstract arrangement. The darks were rendered as a simple unit, using only one general color. Detail is minimized so that a solid picture foundation can be established early in the painting.

2. The individual forms of the subject are developed within the guidelines set up by the first block-in of masses. The darker massed areas of color have been painted into with other colors and a slight variation of tone to give more feeling of depth to the marina. Thinking and painting in simple masses of tone and color provides the artist with a solid foundation and a great deal of control in painting a picture.

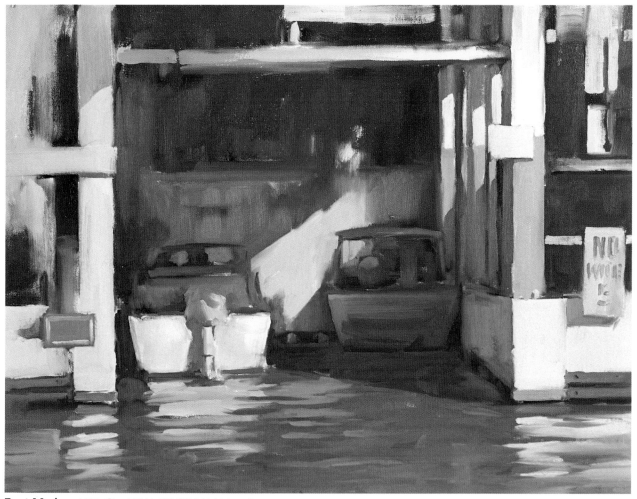

Boat Marina, 1985. OIL, 18″ × 24″ (45.2 × 61.0 cm)

Rectangular Line Divisions Give Control

Whatever is placed within the enclosing borders of the picture rectangle must relate in a balanced way with other things, and because this is such an important concept it is helpful to have some dependable way to control the first placement of these different parts of the picture. One way is to use rectangular line divisions to informally divide the picture rectangle into a series of balanced divisions. These lines are used as a guide in placing the larger masses of tone as well as some individual parts of the subject. Because good picture composition depends on unequal divisions and sizes, these first linear divisions of the picture rectangle should be unequal. The artist must rely on an individual sense of balance and a personal feeling for what seems right in placing these first divisions.

When different individuals attempt to divide a picture area, or to place something within it, it is surpris-

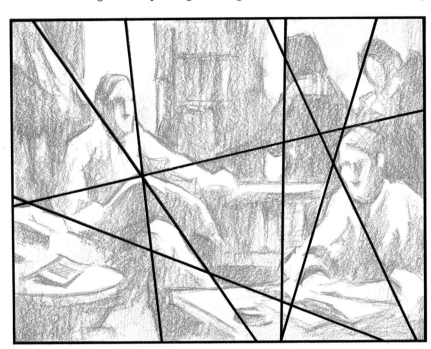

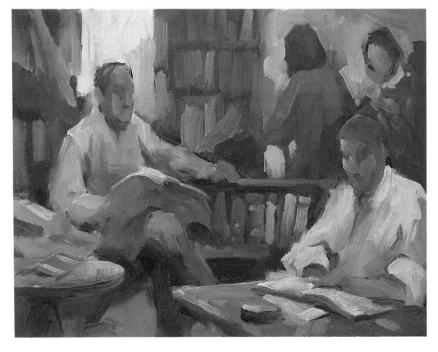

This arrangement is constructed on the rectangular line divisions shown above. Notice how only certain key points of some of the figures touch or align themselves on the line divisions. Sometimes these rectangular divisions will align something in the background with something in the foreground, helping pull together separate parts of the picture to give a more unified appearance.

ing how similar some of the placements will be. This is because, even with small differences, there are certain comfortable balances and divisions that the artist will naturally use.

The viewer's eye can be directed by strong line divisions. It can also be slowed down or impeded. Compare the two illustrations shown here and note the similarity in dark and light tone structure as well as eye movement across the picture.

When beginning a picture with rectangular line divisions, allow some variation in the alignment, otherwise the picture arrangement can become too rigid and stiff. Try to compose your picture with a good balance of its parts, but remember to introduce some variety into your divisions. A good painting has unity but it also has variety.

1. *Notice how the rectangular line divisions in this illustration help hold the arrangement together. The first indication of the dark masses as well as some of the individual forms of the children themselves are placed along these first line divisions.*

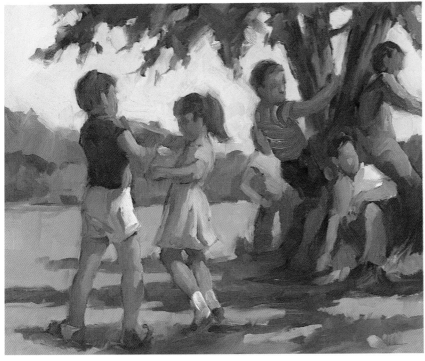

2. *Further development of this picture with tone and color brings out more of the individual figures. However, they are still part of a larger but simpler arrangement based in part on the first divisions of the picture rectangle. Notice how the line divisions only touch certain key points on the figures, trees, and foliage.*

FINDING AND USING THE RECTANGULAR FOCAL CENTER

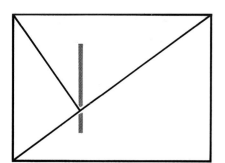

Every picture rectangle has a focal center that will automatically pull the viewer's glance toward it. To find the focal center, first run a line from one corner to the corner diagonally opposite. Now run another line at a right angle from one corner to the diagonal. Where they intersect, place a vertical line. This is the focal center of the picture rectangle. If you wanted to place the focal center on the other side, you would simply run your intersecting line from the other corner.

The one figure to the left of the group is the center of interest because he is placed on the focal center of the picture rectangle and he is somewhat separated from the other figures. When combined with other principles of picture composition and arrangement, using the focal center can help strengthen the center of interest in a picture.

USING LINE AND MASS TO DEVELOP THE PICTURE

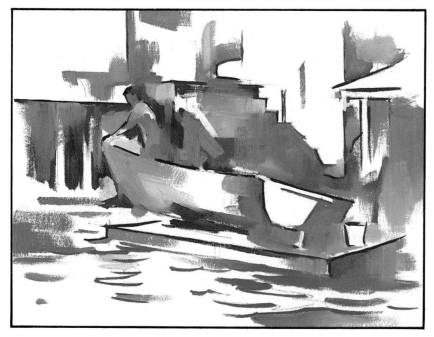

1. The first main lines establish the boundaries of the larger masses of tone and color. Notice how line influences the direction of the viewer's glance as well as pulls the background mass together into a solid unit. The center of interest is the man and his boat, placed a little to the left of the focal center, with the boat leading the eye back to him from the foreground. If other compositional factors are brought into play, then the interest area can be placed a little off the focal center and still be effective.

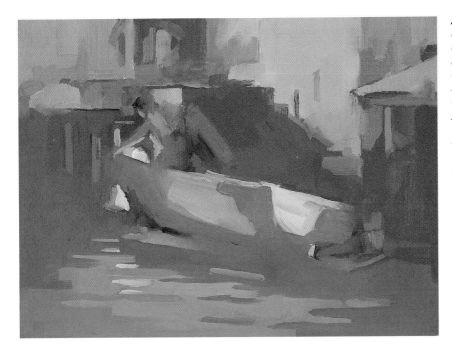

2. *The masses of tonal and color areas are blocked in, pulling together the different parts of the picture. This stage of the painting would be considered a finished block-in, which means that all the basic tonal and color areas plus some of the major forms have been established. Notice the influence of the color harmony and how it further helps establish the man and his boat as the center of interest. If at this stage the painting does not begin to show its final effect then changes should be made before attempting to finish it further.*

3. *The finishing of a painting begins with its block-in. If the block-in gives the desired effect, then perhaps all you need to finish it are some further adjustments of color, definition of edges, and a few tonal accents. This is where the artist's individual sense of the effect wanted directs how "finished" the painting will be.*

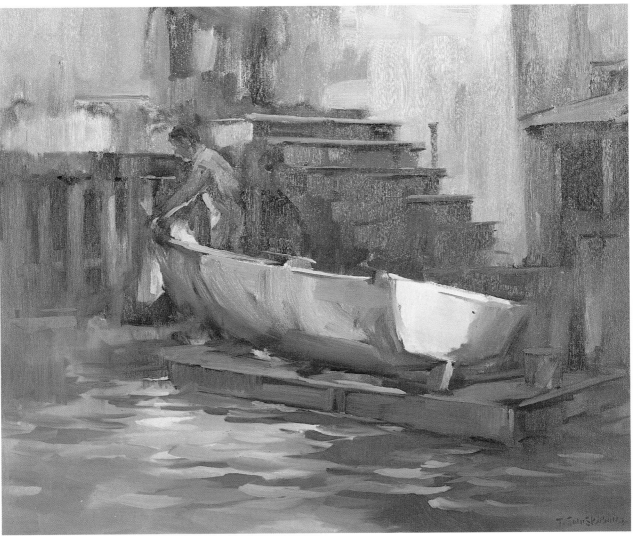

Man with Boat, 1985. OIL, 24″ × 30″ (61.0 × 76.2 cm)

Linear Perspective Gives Depth and Unity

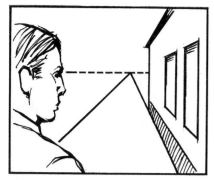

The eye-level line is an extension of the viewer's line of vision into the background. All things recede away from the viewer and converge toward a vanishing point on the eye-level line.

There is another important use of line in the construction of a picture, which adds depth and unity to the composition. This is *linear perspective*. Everything as it recedes into the distance becomes smaller in size, and the knowledge and correct use of linear perspective gives the artist a controlled method of showing this.

The first and probably most important aspect of perspective construction is the correct placement of the eye-level line, which is simply a level extension, all the way into the background, of the direction of the viewer's gaze. The eye-level line is always horizontal, no matter where it is placed. The next important feature is the correct placement of a vanishing point on the eye-level line. If all things gradually become smaller in size as they recede into the background, then eventually these receding things will vanish into one common point.

Loading the Truck, 1984. Oil, 20″ × 24″ (50.8 × 61.0 cm)

The strong receding perspective lines in this painting help give the picture its depth. The viewer's glance is directed into the picture, creating more distance between background and foreground. Notice, too, that the receding lines that are above the eye-level line go into the background in a downward direction, and those that are below the eye-level line go into the background in an upward direction.

The diagram at left shows the main perspective lines of this painting. Notice how the direction of receding lines relate to the horizontal eye-level line. This direction relationship of receding lines can be especially useful when sketching street scenes.

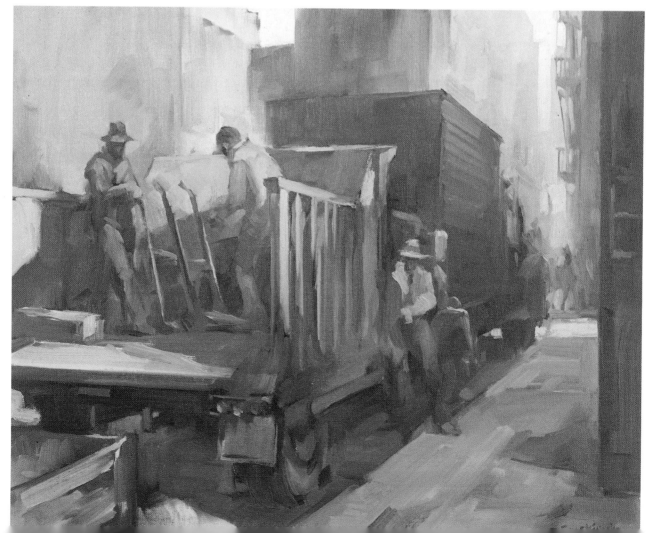

Linear Perspective Helps Unify the Picture

Strong linear perspective construction in a picture can contribute to its unity by relating different things to a single vanishing point. Here, the shadows on the ground, all relating to the same vanishing point, are laid out in one-point perspective. The sameness of direction that a perspective construction gives to a picture that is composed in this way provides a great deal of unity. By keeping the vanishing point out of the picture, you can achieve this unity without your picture construction being too rigid.

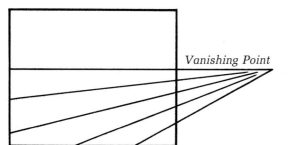

Vanishing Point

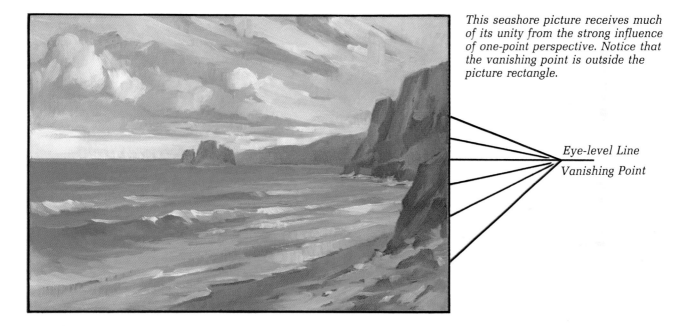

This seashore picture receives much of its unity from the strong influence of one-point perspective. Notice that the vanishing point is outside the picture rectangle.

Eye-level Line

Vanishing Point

Since the eye-level line in a picture is an extension into the background of the viewer's line of vision, if you observe a group of standing figures from a standing position, their heads will align somewhere on or near your eye-level line. People's different heights will result in some variation in the position of the different heads. If you observe the same group from a sitting position, the eye-level line will drop to somewhere near the waists of the standing figures. In this case, then, all the figures will align themselves with their waists somewhere on or near the eye-level line.

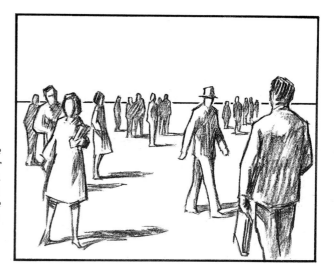

Rhythm Gives Unity and Feeling

The influence of rhythm in making a successful painting is sometimes overlooked or taken for granted by the artist. Rhythmic influences are occasionally evasive and recognized only subtly.

There is always rhythm in the repetitive way that things are constructed, both in nature and in man-made objects. For instance, a city seen from a distance or a bridge spanning a river immediately reveal the rhythmic quality of their construction. In natural things, the effect of rhythm is as prevelant, though perhaps more elusive. Trees and other foliage show definite rhythms in their growth patterns. In fact, each growing thing has its own individual rhythmic growth pattern. Water always displays a strong rhythm in its appearance, whether in the calm surface of a quiet pond or the dynamic forms of crashing surf. Sometimes the influence of rhythm can be felt more than actually seen, such as in the wind blowing through tall grass or in some quiet gesture that someone shows when sitting a certain way.

Rhythmic influences, then, are found everywhere. Sometimes they are easy to see and at other times they are only subtly suggested. Rhythm, with its repetition of forms and actions, gives cohesiveness and unity to a picture.

**THE INFLUENCE OF RHYTHM AFFECTS
A PAINTING'S APPEARANCE.**

Playground Under the Trees, 1983. OIL, 20″ × 24″ (50.8 × 61.0 cm)

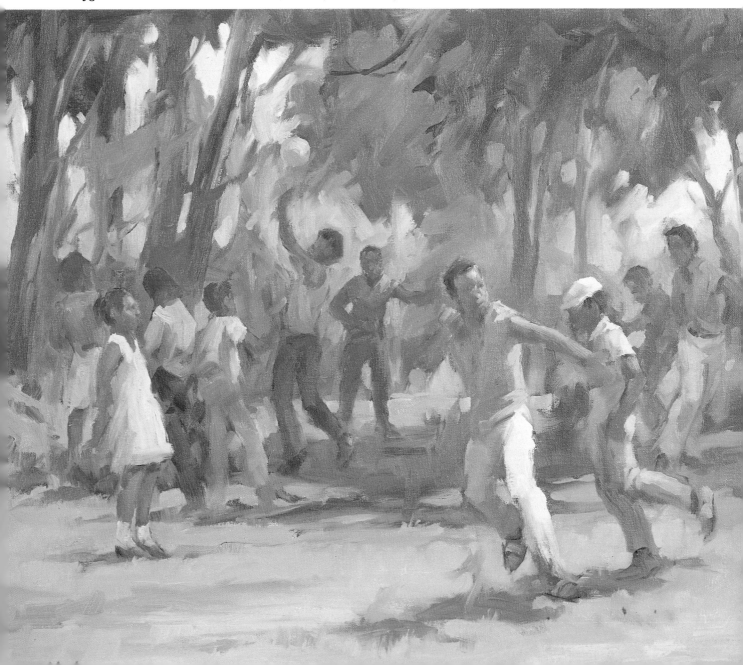

In this analytical illustration of the painting on the opposite page, the rhythmic influence of brushstrokes and different tonal shapes is shown. Like any other compositional influence, rhythmic movement in a picture has to be arranged in a balanced way. Notice how the brushwork and shapes follow a certain pattern of movement, in some areas quite rapid while in others slower or even static. Action in the children is shown by balancing the more active figures against the static ones.

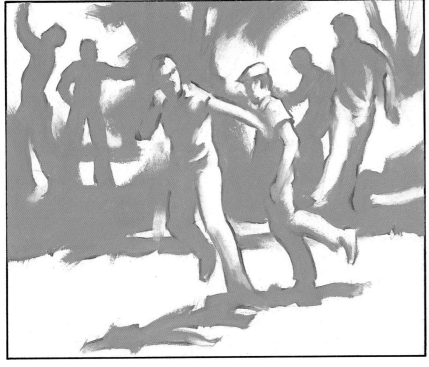

Many times a group of people show a strong influence of rhythm in the way they group themselves together or portray a similar action. Here, rhythm contributes to the unity of the arrangement by pulling together separate and individual children. Notice the use of tone in the arrangement of figures, which contributes to the rhythmic construction, and also how line affects the feeling of movement throughout this arrangement.

In actual painting, take care not to use pronounced brushwork or other surface techniques to achieve a rhythmic effect. Every painting must have a central idea or purpose that portrays a subject as it is seen by the artist. Although rhythm can certainly help the effect and feeling in a painting, excessive use of brushwork and other strong painting techniques can distract from a good pictorial idea. Rhythm has an important influence on a painting's appearance, but should never be forced into a picture. Excessive use of rhythm can be distracting. It is better to *feel* rhythm in your technique rather than *see* it.

Chapter Five
OBSERVING WITH A SKETCHBOOK

Direct observation and sketching from life, or even from memory, is one of the most important steps in developing a subject into a finished painting. In order to successfully paint an interesting subject, it is first necessary to see and understand it, and sketching gives an artist an excellent method of achieving this. Every potentially good subject has certain basic construction features and lighting effects that will reveal themselves through the sketches.

Although sketches are generally considered studies and not finished pieces, there are occasions when a sketch can be a complete and finished rendering of the subject—when it has all the necessary elements and qualities, and truly and completely reflects the way the artist sees the subject.

Sketches can be line and tone drawings or more elaborate color studies rendered in paint or pastel. Line and tonal arrangements of the basic construction features of any subject can be easily and quickly indicated with a minimum of equipment—a pad of drawing paper and a few soft dark pencils. With pencil, even a short twenty-minute direct study can record much valuable information for future use. Color sketches in paint require a little more time and effort to complete, but they too can be either simple, rough renderings or more involved and finished studies.

**SKETCHING DIRECTLY FROM LIFE
HELPS THE ARTIST TO SEE.**

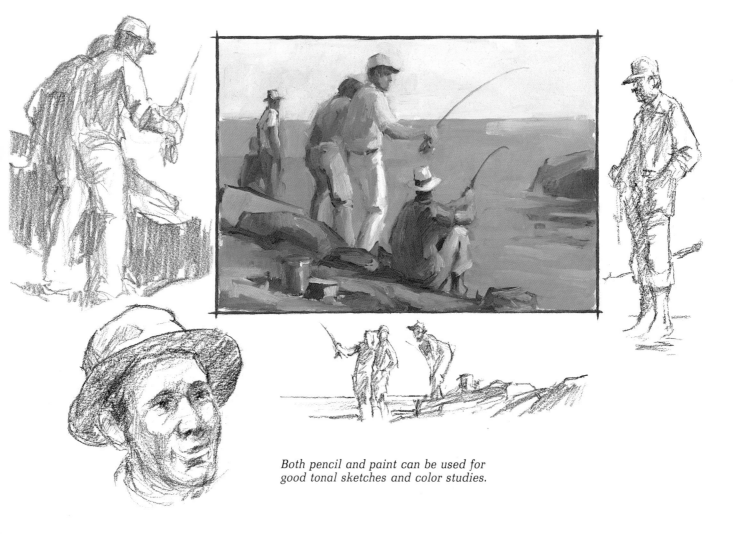

Both pencil and paint can be used for good tonal sketches and color studies.

Looking for Basic Construction Features

The first step in making a sketch is to draw the basic line construction to show the major tonal areas and some form. Detail in the drawing at this stage is not necessary.

Put in the basic dark and light tonal areas to establish a good picture foundation for future finishing. Remember to keep the tones simple and flat.

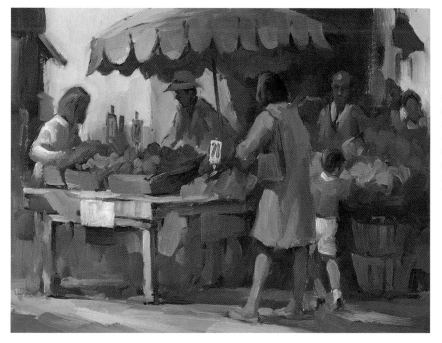

Using a limited color palette of three colors can help the artist develop a strong but simple color harmony in the sketch. In this finished type of color sketch, a solid dark and light tonal arrangement was first made of the subject. You can use one-color or two-color palettes for effective studies as well.

Through sketching, beginning with the basic construction features, the artist can explore different approaches to developing a subject into a finished painting. Some subjects may call for a linear influence while others may call for a massed-tone approach. In the beginning stages, excessive detail should be avoided. Concentrate instead on simple divisions and proportions and on the basic dark and light tonal areas. It is also a good idea to do a number of different sketches of the same subject in order to find the approach that best suits it.

The Graphite Drawing Pencil and Its Use

Of all the different possible sketching materials available to the artist, the ordinary graphite lead drawing pencil is certainly the most familiar; it is both easy to use and readily available.

There are many different kinds of graphite pencils and they are numbered according to hardness or softness. The letter *H* following a number, such as *2H,* signifies a harder drawing lead. The letter B following a number, such as *2B,* signifies a softer drawing lead. As the numbering increases, it means either a harder or a softer pencil. I find that the softer leads, the 2B and 4B pencils, because of their richer tones, produce the best results in sketching.

Another type of graphite lead drawing pencil that is a good sketching tool is the one made specifically for layouts and other quick drawings where a rich dark and middle range of tone is required. There are several such pencils on the market under various brandnames.

One of the reasons that the graphite drawing pencil is such a convenient and versatile sketching tool is the wide range of effects it can produce on the many different types of drawing papers. Each different-surfaced paper will give different effects. For instance, a paper with very little tooth, or surface, will give a wide range of middle and light tones to a drawing. A rough paper restricts a drawing to more contrast between the darks and lights. Sometimes a paper made specifically for a medium other than pencil, such as charcoal or pastel paper, watercolor paper, and even ordinary matboard, will give interesting results when used with a pencil.

Different ways of using a graphite drawing pencil

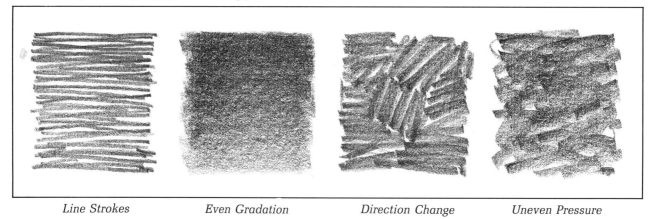

| Line Strokes | Even Gradation | Direction Change | Uneven Pressure |

Paper surface and its effect

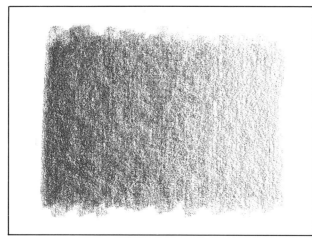

Tonal gradation on a smooth paper with little surface tooth.

Tonal gradation on a rough paper with much surface tooth.

THE TONAL STUDY SKETCH WITH PENCIL

When sketching with a pencil, use line to indicate the major dark and light tonal areas as well as certain shapes of form. You can then add a strong middle tone where indicated by the lines. This establishes the basic dark and light mass construction of the picture. The drawing pencil is very adaptable to a line and mass approach to sketching. With a small sketchpad, it is easy to carry and can be readily available at all times.

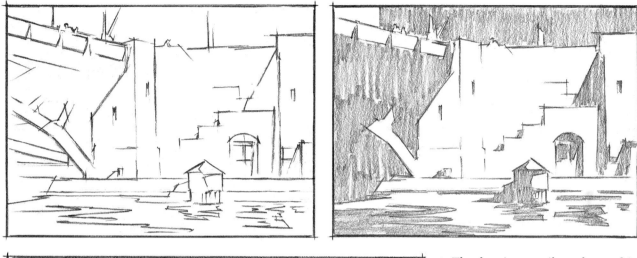

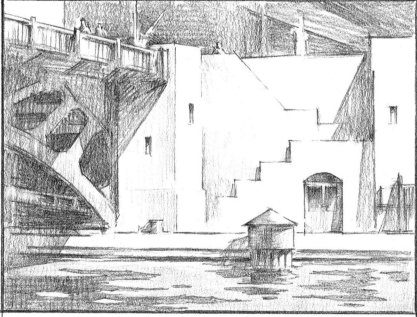

1. The drawing pencil can be used in the beginning stages of a sketch to indicate where areas of tone will be.

2. The large masses of dark, using the middle range of tone, are put in where indicated by line.

3. The sketch is finished by working into the dark and light masses with different tones, making some edges stronger and more defined while losing or softening others. Beginning a sketch with line and mass gives the artist a good foundation on which to further develop the subject.

Other Sketching Materials and Their Uses

Besides the graphite lead drawing pencil, there are several other good sketching materials:

Charcoal or carbon pencils are made of compressed charcoal and available in several different degrees of softness. The numbering is the same as the regular lead drawing pencil, with the higher B number being softer and the lower number harder. Charcoal pencils are convenient to use and give deep, rich, dark tones. They can give fine or broad line effects as well as large passages of tone. If rubbed with fingers or a paper stump, the tonal effect will change considerably. It is necessary to spray the finished drawing with fixative because charcoal pencil work can rub or smear.

Conté and lithographers crayons are excellent drawing mediums that lend themselves to a mass-indication type approach. The conté crayons are available in several different red-brown colors, and are approximately ¼″ square. They are capable of broad strokes, and used sideways they can develop large areas very quickly. If a sharp corner is maintained on one or two edges, the crayon can also indicate fine lines. Rubbing is an excellent way of working with conté crayon. Lighter areas or accents can be lifted out with an eraser. Conté crayon is also somewhat water-soluble and some interesting effects can be achieved using a wet brush over it.

The lithographers, or litho, crayon is a wax-base black crayon that also gives large mass strokes and line effects. It is available in several degrees of hardness of softness, corresponding to lithographers pencils.

The felt-tip marker pen is an ink-type drawing instrument that uses a felt nib to transfer and apply the ink to the paper. Since it uses ink (most marker pens are of the waterproof-ink variety), the resulting work can show much more strength than a pencil. However, marker pens do not show the subtle variation in tone that drawing pencils do. For this reason they are more a direct type of sketching medium, and can produce deep darks and much contrast. Felt-tip markers come in a variety of nib shapes and sizes. As in any ink medium, subtle tones must be rendered with some form of crosshatching or fine linear strokes. Sometimes, if the marker is almost dry, a broken, drybrush effect can be achieved with light pressure.

The wax-base colored pencil is a good color-sketching medium in pencil form that is useful where quick color indications are necessary. Seeing that it has a wax binder, it does not erase or blend too easily. If the artist has a large enough selection of colors and plans what the major color areas will be, this does not present much of a problem and many interesting color effects can be achieved. When using the colored pencil, apply one color stroke directly over another to produce optical color blending. I find that to obtain clean, vibrant color effects with this pencil, it is necessary to use a crosshatching technique and to avoid rubbing the colors together excessively. Although there is a limit to the range of color effects that colored pencils can give, they can be a very convenient way of indicating color, especially in a small sketch.

Using pastels is another convenient way to make color sketches. Their use is covered in detail in Chapter 10.

EACH MATERIAL GIVES A DIFFERENT EFFECT

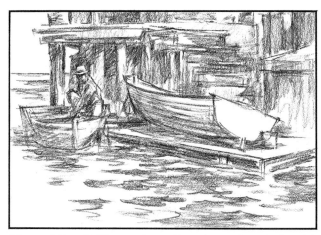

Charcoal Pencil. *Charcoal pencil produces deep darks with a good range of subtle tone variation. Masses of dark can be easily put in with good edge control. Notice the use of line and mass in this picture. As with any drawing medium, the paper's surface will influence the drawing's tonal effect.*

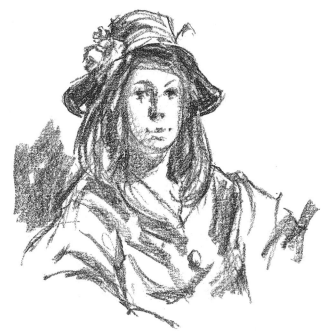

Conté Crayon. *Using conté crayon, an artist can quickly build up tone in a drawing. Here, the warm tonal effects of conté crayon helped establish the over-all effect of this subject early in the drawing. Even though the conté crayon gives a natural mass approach to drawing, some strong line work can still be indicated with ease.*

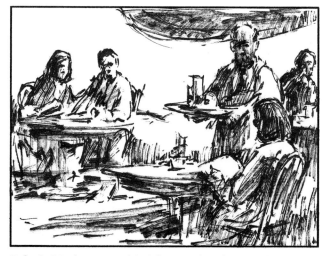

Felt-tip Marker Pen. *This ink-type sketching tool produces deep darks and a great deal of contrast. Subtle tonal areas can be indicated with linear strokes or crosshatching. With this medium it is easy to maintain a strong and definite dark tonal structure from the very beginning of the sketch.*

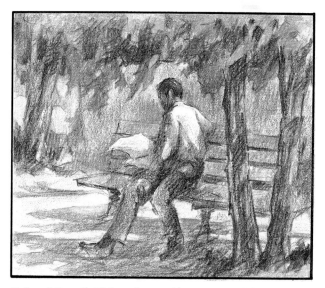

Colored Pencil. *This color medium in pencil form makes a good sketching tool where quick color indications are necessary. Colors applied in individual strokes directly over each other give clean and vibrant color effects. In this color sketch the colored pencil was able to give an airy and open feeling to the shadow areas.*

Sketching Gives a Close Study of a Subject

It is through sketching that a close study of a subject can be undertaken. Several different things make this possible:

First of all, important basic things are observed and recognized. Through sketching, the artist learns to see a subject clearly or to recognize other potential subjects.

Different ways of rendering the subject can be tried in order to achieve the best effect. The brief amount of time it takes to do a sketch encourages more than one approach to be attempted with the same subject.

When sketching, adjustments and changes can be easily made. Most sketching material allows for a certain amount of correction and change. Since sketches are generally not considered finished work in themselves but only preliminary studies or observations, they can be rendered with more freedom.

Finally, through sketching the artist can obtain valuable information for future use. Not only can sketching provide material and ideas for other work but it also gives the artist experience in rendering different subjects and their individual effects.

SEVERAL DIFFERENT APPROACHES CAN BE TRIED FOR THE BEST EFFECT.

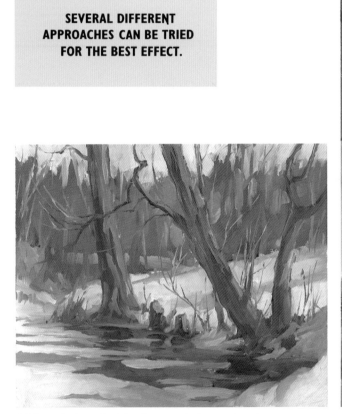

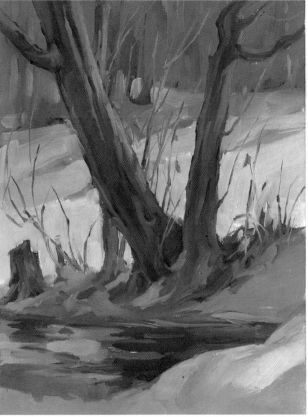

This painting sketch of a wooded area in winter was composed to show the depth and fullness of the woods. The partially frozen stream as well as the open snow-covered field help to achieve this effect. Individual trees are shown only in the foreground; they are massed together in the background.

A different effect was achieved in the same subject by using a verticle arrangement and with more contrast in the two vertical trees in the foreground.

GOOD SKETCHING PROCEDURE IS IMPORTANT

There are often time limitations or changing conditions when you sketch, so it is important to have a method that is quick and precise. Before actually beginning the rendering, spend some time in visually studying your subject. Make sure that you know how the larger masses of the picture will be arranged. It is also important at this time to clearly understand the purpose of your sketch and what you want to show and say about your subject. Knowing and understanding the purpose of your sketch in the very beginning will help you control its development so that it successfully captures what you see and wish to convey.

Once you have studied and thought about your subject it is time to proceed with your sketch. Here are some basic guidelines that will help you establish your ideas in an orderly way: (1) use a viewfinder to isolate the subject; (2) squint to see the basic tonal and color relationships; (3) begin the sketch with the simplest of basic forms; (4) use line and mass together in the beginning stages; (5) be prepared for the unexpected.

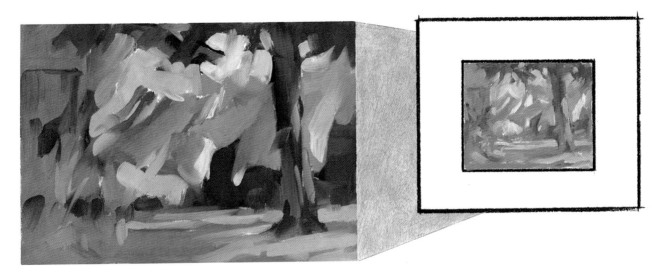

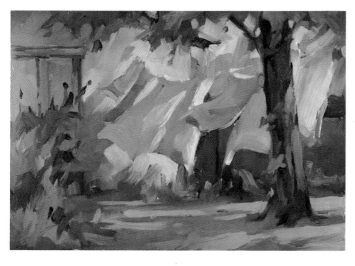

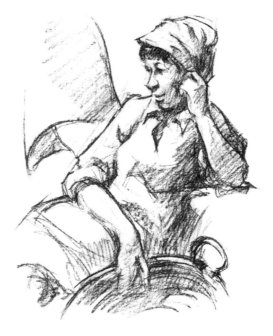

Occasionally when sketching a given subject, the artist will see something entirely different. Sometimes this new subject is connected with what is being sketched and it is possible to incorporate it into the sketch. At other times it may be a completely different subject that would make a good study in itself. Being always prepared for unexpected subjects is an important part of sketching.

Direct Sketching from Life and Memory

You learn by painting and sketching directly from life and memory. Life is the best teacher for the artist. Wherever you are, there is always something to see and study. If you understand some of the basic things that go into the making of a good painting, then observing directly from life will reveal many of these things to you. When you see an interesting subject, you will know what makes it appear that way.

Developing your ability to see through direct sketching from life will also improve your proficiency in working from memory. The ability to work successfully from memory depends on having a clear idea of what was seen earlier and what made it appear the way it did. One night while at a carnival, I came across an interesting view and was greatly impressed by it. Having only a small sketchpad on me, I sketched out some ideas of what I was looking at and also made some notes about my subject. On these pages I will explain the procedure I used in developing my ideas into a painting.

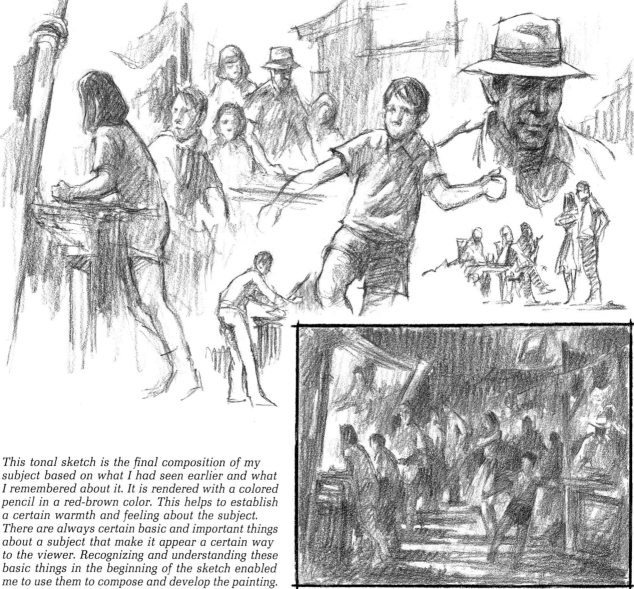

This tonal sketch is the final composition of my subject based on what I had seen earlier and what I remembered about it. It is rendered with a colored pencil in a red-brown color. This helps to establish a certain warmth and feeling about the subject. There are always certain basic and important things about a subject that make it appear a certain way to the viewer. Recognizing and understanding these basic things in the beginning of the sketch enabled me to use them to compose and develop the painting.

DIRECT STUDY FROM LIFE IS NECESSARY FOR GOOD MEMORY PAINTING.

USING PAINT TO DEVELOP THE IDEA

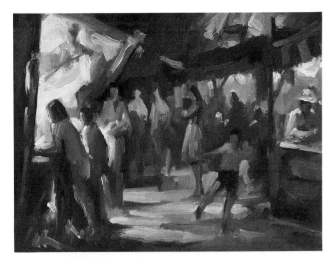

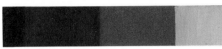

After working out the basic picture composition with pencil, I developed this idea into a tonal painting. Using only a neutral black color, I was able to concentrate on tone arrangement, balance, and painting effect at this time. The pictorial effect that I wanted for my idea was a carnival night scene. This made it necessary to use a larger range of dark tones with smaller areas of light. First painting an idea with one neutral color in paint enables the artist to explore different techniques and approaches for developing that idea.

Carnival, 1984. OIL, 14″ × 18″ (35.6 × 45.2 cm)

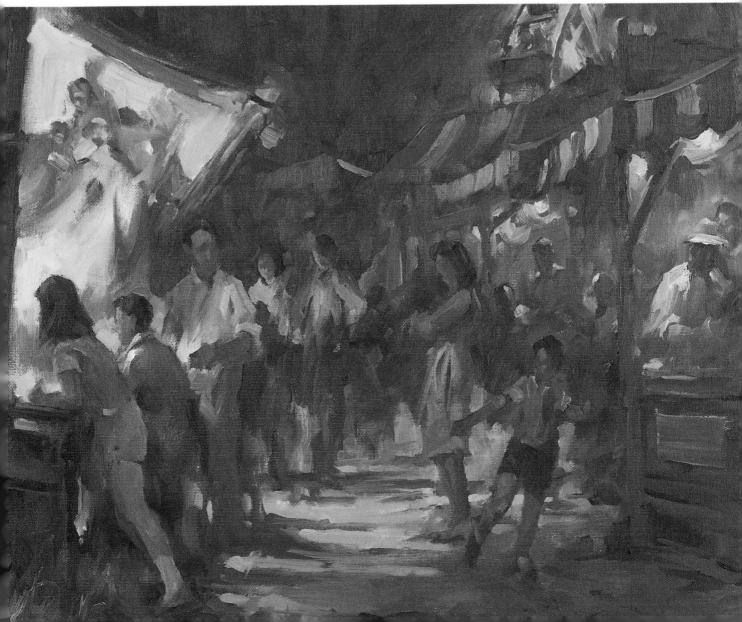

Developing Sketches into a Painting

Even if there is little time in which to make a detailed study of a subject, you can put down enough information about it so that you can later develop it into a more finished painting. But you have to cultivate the habit of careful observation, which means to see only the important things about the subject and to be aware of how these things relate to each other. Good sketches develop from careful observation. If you have a good sketch and a strong impression of your subject, then you probably can work it up into a finished painting.

1. The first step in developing sketches into a finished painting is to work out the composition of the subject. I was only able to sketch these street musicians briefly, and make some descriptive notes while observing them. It was not until later that I decided to attempt a painting of the subject. Working from my rough original sketches and from memory, I sketched out the figures and the picture composition with a charcoal pencil, concentrating on developing a solid tonal arrangement.

2. *After having worked out a good tonal arrangement for this subject, I then began to develop the color harmony. The first color roughs were small and very simply rendered, almost abstract in appearance. When a satisfactory color combination was formed, then the picture's composition was sketched out with it as shown. This was only a preliminary color sketch so I avoided excessive detail and finish, however the original tonal composition was closely followed. The final version of the painting was developed using this preliminary work and my memory as reference.*

SKETCHES FROM DIRECT OBSERVATION CAN BE USED FOR A PAINTING.

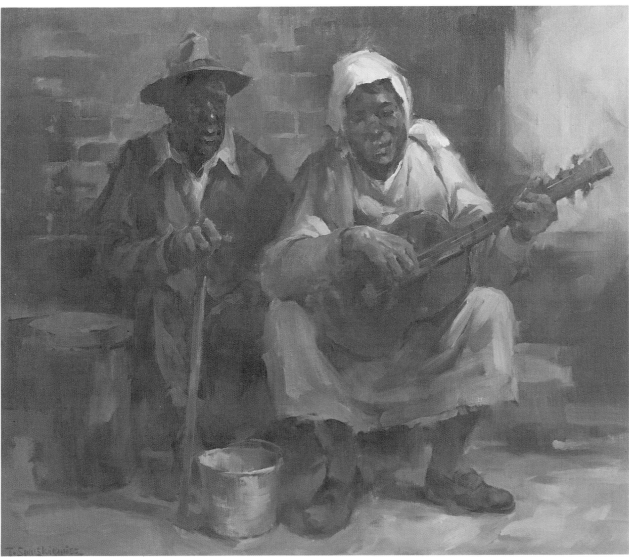

The Street Musicians, 1985. OIL, 20″ × 24″ (50.8 × 61.0 cm)

Thumbnail Sketching of Your Ideas

The use of small and simply rendered drawings called "thumbnail" sketches enables the artist to quickly explore all of his or her ideas about a subject. Only the important basic elements of the subject are included in the thumbnail sketch. Usually the dark and light tonal structure is the first thing to be observed and indicated.

Being no more than a few inches in length, and many times even smaller, the thumbnail sketch allows a rapid indication of the subject in a visual manner. It is one thing to just see and think about something, but until that idea is drawn in some type of picture form, it is impossible to really see it. Doing thumbnails of what you see can help you visualize the finished picture much more clearly and can give you a good indication of the right direction to proceed with in its development.

The artist should also attempt to do occasional memory sketching. It is surprising how much diverse and valuable information about a subject can be retained through careful observation. This information can be used later to draw thumbnail sketches that can provide the beginning of the development of an idea into a finished painting.

Using thumbnail sketches. Knowing in what direction to proceed is important in good painting procedure. Unless several different possible approaches are attempted, it is difficult to make the correct decision as to which way would be the best for a particular subject. Doing these small preliminary thumbnail sketches helps the artist choose the best way to develop a painting.

When doing a thumbnail sketch, the dark and light tonal arrangement is indicated in the beginning. In sketching from life, remember to squint and use a framing device so that you will be able to see the basic tonal areas more easily. Avoid putting in excessive detail. Stay with the larger basic elements. If you restrict the sketch to three basic tones (dark, middle, and light), it will make this first rendering of the subject much easier. Later, some line and edge control can be developed in the sketch to give it more dimension, but remember to keep the drawing simple and not too involved.

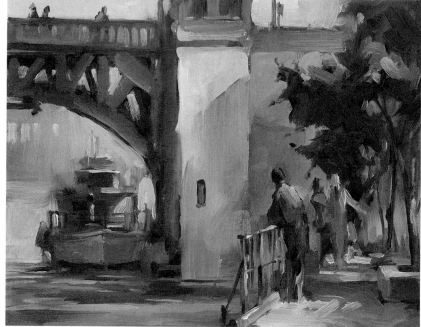

After the idea has been roughed out in the first few thumbnail sketches, it can be further developed in oil paint. By using only one dark neutral color and white, the tonal arrangement and general painting effect can be worked on.

When working in color, it is possible and very helpful to do small color thumbnail sketches. This further use of thumbnail sketches as they apply to color will be covered in more detail in the next chapter.

THE ADVANTAGES OF SKETCHING FROM LIFE

Although a camera can be a useful tool when used creatively, I personally do not use a camera when I sketch or paint. I prefer to work by direct sketching and painting from life or memory. Painting to me is enjoyment, and I enjoy becoming involved with my subject through direct work from life. When I see something that impresses me, I am seeing it that way because of certain arrangements and balances in the subject that I am aware of. We as individuals all see things differently. When a camera photographs something, it shows everything there is without much selectivity or arrangement. I think that when artists begin to depend on a camera too much and fail to study and work directly from life, a certain amount of individuality can be lost in their work.

When you sketch or paint directly from your subject, you can see the picture develop before your eyes and judge its appearance immediately. As you work out your sketch, you can compose and arrange it to show just what impresses you and how you feel about what you see.

Become involved with your subject through direct study and spend some time with it by observing it with a sketchbook. Trust yourself to look closely and believe in your feelings. You will be surprised at what you discover.

> **IT IS ONLY THROUGH DIRECT OBSERVATION AND SKETCHING FROM LIFE THAT THE ARTIST CAN TRULY SEE AND INTERPRET.**

The Water Children, 1983. Oil, 18″ × 24″ (45.2 × 61.0 cm)

Chapter Six
THINKING IN COLOR

Color has an influence on everyone, sometimes subtle and at other times quite strong, whether they are artists or not. But the artist is perhaps more finely attuned to the power of color. Just by choosing certain color harmonies or by changing them, the artist can easily alter a painting's effect. Sometimes a troublesome painting can be successfully completed by a slight change in the color harmony and balance. At other times it may be necessary for the artist to completely rethink the way that color is used in the picture. Color not only contributes much to the overall appearance of a picture but can also greatly help the artist to depict his or her feelings and emotions about a particular subject.

Although much can be accomplished by using color correctly, remember that color itself does not make a good picture. The many different construction features of a painting, its tonal structure in particular, have to work together with color toward developing a good painting.

> **ALTHOUGH A SOLID TONAL STRUCTURE IS IMPORTANT TO A GOOD PAINTING, COLOR HAS A STRONG INFLUENCE ON THE PICTURE'S FINAL EFFECT.**

Farmyard with Tractor, 1984. OIL, 18″ × 24″ (45.2 × 61.0 cm)

Color Affects a Painting's Appearance

Any change in color harmony and balance will alter the way a picture appears. Certain subjects call for a particular color harmony in order to achieve the desired effect. For instance, a night scene, especially if it has moonlight in it, calls for blue or some other cool color. If an artist is painting a scene illuminated by firelight, then much warmer orange and red colors must be used. However, there are many other subjects that are adaptable to color change. They would not lose their identity but there would be a change in feeling or mood. The way that an artist uses color has a lot to do with the way he or she sees and feels about a subject.

Although it is possible to use different color harmonies to get different versions of the same subject, every subject must have its own particular tonal balance and arrangement. The tonal construction can be in a full-key range or a more narrow key, but it is necessary that the picture have the basic lights and darks in the correct places. A particular lighting situation presents a particular arrangement of lights and darks. An artist working only in tone is restricted to using perhaps only ten or twelve different tonal gradations from black to white, and although beautiful and very effective paintings and drawings can be rendered using only tone, a much larger range of pictorial effects becomes possible when full-color or even limited two-color harmonies are used.

Color makes it possible for the artist to show a subject in the fullest possible manner, to completely express an idea or emotion.

CERTAIN SUBJECTS NEED A PARTICULAR COLOR HARMONY

Although a night scene may be developed with a warmer color harmony, cooler colors, such as blue, seem to better evoke the feeling of night and moonlight.

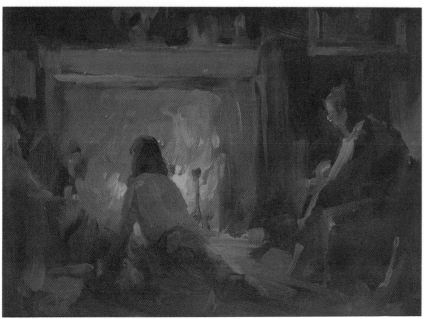

The warmer colors of yellow and orange are necessary in a picture showing the full effect of a fireplace in a darkened room.

Understanding Basic Color Principles

Let's take a closer look at color. Like anything else, color can be analyzed and broken down into its component parts. All color originates from the primary colors: *yellow, red,* and *blue.* All other colors can be mixed from these basic colors. This statement should be clarified, however. When color pigments are mixed, in order to obtain a full range of all the colors, it is necessary to use more than the single primary colors of yellow, red, and blue. Sometimes several of each of the primary color pigments are needed. For instance, one single red pigment cannot be used to mix both a clear, intense orange and an intense violet.

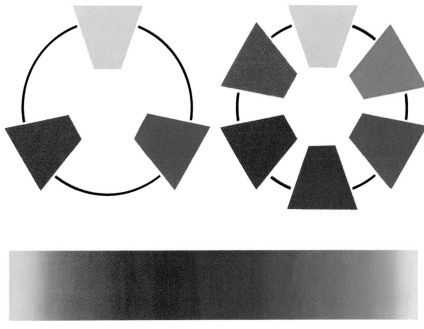

All colors originate with the primary colors of yellow, red, and blue.

I. HUE OR FAMILY OF COLOR

The first component part of color is its basic hue. If the three primary colors are mixed together in pairs, they will expand into the secondary group of colors: *orange, violet,* and *green.* These six colors, the primaries and the secondaries, are the basic family of colors from which all other colors originate. They are called the basic hues. Through continually mixing adjacent colors together, a series of closely related colors such as yellow-orange, red-orange, red-violet, etc., are obtained. This continual adjacent mixing of the primaries and secondaries with each other will finally produce an unbroken color ring. Every color originates with and can be first identified with a basic hue. For instance, an olive-green color can be identified with a yellow-green hue, a warm brown color with orange-red, and a very cool gray color with blue.

The Color Ring of Hues

ANY COLOR CAN BE REDUCED INTO ITS BASIC COMPONENT PARTS.

2. TONAL VALUE

The second basic part of color is its tonal value. Every color has a tonal value on a tone value scale. The darkest colors are not really black and the lightest ones are not really white, otherwise it would be impossible to identify them as colors at all. Some colors appear darker, some lighter than they actually are. For instance a red-orange of full intensity can appear lighter when it might actually be slightly darker. Squinting is an excellent way of accurately judging the true tonal value of a color.

When mixing a color, remember to correctly judge its tonal value, otherwise you will have problems along the way in obtaining the color you want.

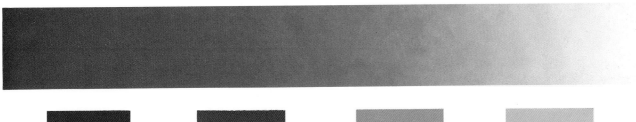

Different colors can have the same tonal value.

3. INTENSITY OR SATURATION

The third component part of color is its intensity, or saturation. A basic hue on the color ring of hues is at full saturation. By gradually adding some of the color that is directly opposite to it on the color ring, the original color can be made less saturated. If enough of the opposite color is mixed into this original color, it will lose all of its identity and become a neutral color. In this state of mixture, the color is no longer saturated with the original color. Although many colors found in nature are not of a full intensity, or saturation, they can still be identified as having their origin in a certain fully intense basic hue. Keeping the same tone in a similar colored form but changing the intensity or saturation of that color is a way in which an artist can show surface change in a form.

The intensity or saturation of a color is reduced by the addition of its opposite.

Full Intensity or Saturation

Reduced Intensity or Saturation

Seeing and Mixing Good Color

Good color mixing is an orderly procedure that enables the artist to know exactly where he or she is going at all times. The first step in seeing and mixing a color is to identify its basic hue, or the family of color to which it belongs. The next step is to determine the tone value of the color. The final step is to judge the color's intensity, or saturation. To reduce the intensity of a color, add a little of the opposite, or complementary, color to it until you reach the desired effect.

With a warm light on a subject, the shadows are cooler. Using blue in the shadow areas in the beginning stages of a painting helps establish the correct effect of the shadow color. The basic families of colors seen in the lighter areas are indicated more intensely than the final colors desired. Remember, every color has its origin in some basic hue and it also has a certain tonal value.

The final effect of color in the subject is achieved by adjusting the beginning block-in of colors to the correct intensity or saturation. Reduce the intensity of a color by adding the opposite, or complementary, color to it. The appearance of a color's intensity or saturation can be affected by the surrounding colors. Sometimes a little adjusting of a neighboring color is all that is needed to achieve the right effect.

COLOR EXERCISES TO HELP IN MIXING COLOR

You can improve your skill in seeing and using color by rendering these simple but effective exercises in color mixing. To receive the most benefit from them, you should do them repeatedly and in a controlled manner. Use some ¼" masking tape to separate the individual color squares. The color can be applied with a paintbrush or a painting knife. With practice, you will be able to do some variations on these exercises to make them more interesting and more suited to your individual needs.

1. Gradually add white to a color to lighten it. This should be done with all the basic pigment colors and also different mixed colors.

2. Starting with a pure pigment color, add white to it in order to make a controlled and graduated tonal scale from dark to almost white. Avoid any abrupt change in tone, and remember, squinting will help you judge the correct tonal value.

3. Mix different colors of the same tonal value. Be careful to accurately judge the more intense colors against colors of lesser intensity. Use whatever colors you want, but always keep the tonal value the same for all the different color mixtures.

4. Starting with a fully intense and saturated color, reduce its intensity while maintaining the same tonal value throughout. This is accomplished by gradually adding its opposite, or complementary, color. Use an opposite color of the same tonal value as the original color.

Color Is Affected by Its Surroundings

There are occasions when a color will appear to be something that it actually is not. Color appears to us not only because of what it is itself but also because of its relationship to other colors. In the three illustrations of the yellow hat on this page, the same yellow has been used, and the backgrounds are all of the same tonal value. However, as you can see, the hat appears different in each illustration. The first yellow hat is against a much darker yellow background and so does not appear as light as the other two hats, which are placed against darker backgrounds of an opposite and neutral color. The other three illustrations have the same color pink square in all of them, but again, because of different backgrounds that same pink looks different in each one. So you can see that an important quality of color is that its appearance is always affected and influenced by the colors that surround it. Sometimes, when an artist is having difficulty in making something appear a certain way, all that may be necessary is to change the background or some neighboring color.

A yellow background behind the yellow hat gives a unified effect to this picture without an appearance of contrast.

The same yellow hat looks brighter and lighter against a background of the opposite color family.

A neutral background appears cooler and also makes the same yellow hat look brighter than the first one.

The same pink square appears darker but still unified with a lighter blue background.

A darker background of green makes the same pink square appear much lighter and warmer.

A darker background of red makes the same pink square appear lighter but much cooler.

Neutral colors have an important influence on the appearance and balance of color. In the illustration at left, the red appears darker against the lighter neutral background. In the illustration at right, because of the darker neutral background, the same red appears much ligher and more intense. Neutral colors are necessary to balance the pure and intense colors. Darker neutral colors will make lighter colors appear to be more intense than they actually are.

In the illustration at left, the lighter green is placed against a darker green of strong intensity or saturation. In the illustration at right, the same green appears much more intense when placed against a more neutral or less-intense green background. Without the use of neutral colors in a picture, the brighter colors lose some of their power. The brighter and more intense colors need neutral or less-intense colors to balance against in order to appear fully effective.

Color appears a certain way because of the temperature of the light that illuminates it. If an orange-colored surface illuminated by a warm light begins to gradually turn away from the light, it becomes slightly darker and cooler in temperature, as shown at right. Changing the temperature of color is an important way of showing the surface change in a form. A reduction in the intensity of the orange occurs when an opposite color is introduced to change the temperature, resulting in a more neutral color.

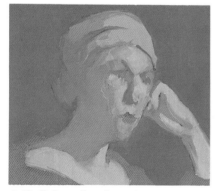

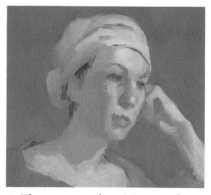

REDUCING THE INTENSITY

Learning to recognize the basic families of color is the start of good color mixing. The stronger and more intense colors of the first block-in can easily be reduced by adding opposite colors to the mixture. For a picture to be well balanced in color and for the natural forms to show well, it must also have a certain number of neutral and less-intense colors.

1. If all the colors in a picture are pure and intense, then the natural effect of light and form is lost.

2. The grayer or less-intense colors balanced against the more intense colors are necessary in a picture in order to produce a natural effect of light and form.

Making Color Work for You

When developing the color harmony of a painting, the subject itself should be given first consideration. Certain subjects call for specific colors, and to change them can alter that subject's appearance considerably. Colors that work well for one subject will not necessarily do for another. The next consideration should be the effect and feeling that the artist wishes to capture. Even though the tonal structure of a painting is important in depicting the feelings and emotions of the artist in regard to the subject, color also has an enormous influence. Finding the right color harmony depends, then, not only on the physical reality of the subject but also on the artist's emotional impressions.

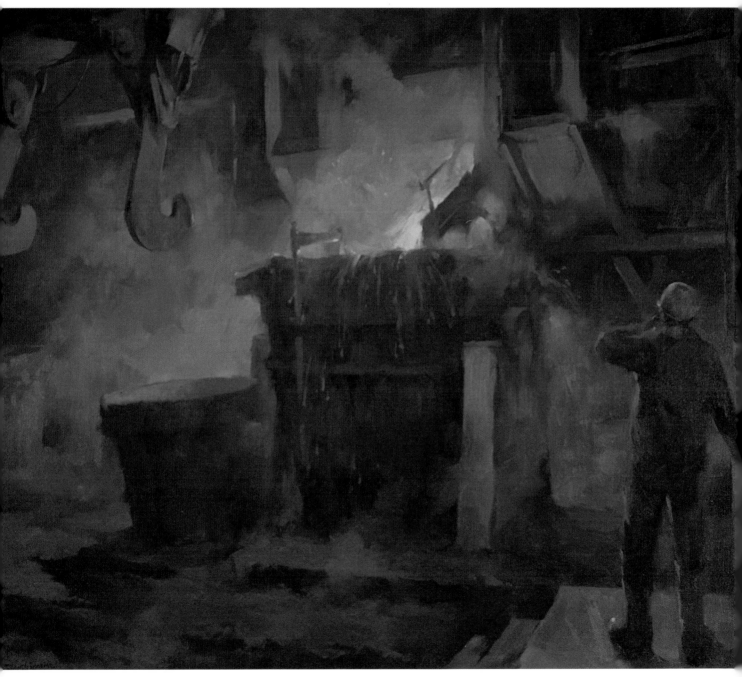

The Steel Furnace, 1979. OIL, 30″ × 36″ (76.2 × 91.4 cm)

I painted this picture from direct observation in the pouring pit as the furnace was being tapped. Because of the brilliant and overpowering light of the molten steel and the heat and atmosphere in the pit, I used a warm color harmony in the orange family. Also, I maintained a strong contrast in the tonal arrangement in order to achieve the maximum effect of brilliancy.

COLOR BALANCE AND COLOR HARMONY

Just as the line and mass arrangement of a picture must be balanced and arranged correctly for the best effect, the colors that are used must also be arranged throughout the picture area in a balanced manner. The tonal qualities of color, as well as its saturation, contribute much toward an effective painting.

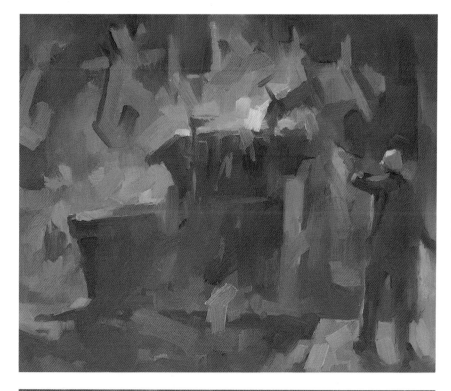

Color balance. Certain types of balances must be followed in arranging colors. Intense colors or colors of a pure hue should occupy smaller areas and more neutral colors should occupy larger areas. Another important balance is between warmer and cooler colors. Even in a picture with a harmony of basically warm colors, there must be some of the opposite or cooler colors for good balance. Finally, the light and dark tonal arrangement must be correctly balanced and arranged in order to effectively show the colors that are being used. In painting this picture, I used all these forms of balance to achieve the effect I wanted.

Color Family of Orange

Color harmony. In this particular subject, because of the strong influence of light from the molten steel, I selected orange as a dominant color for the color harmony. All the colors in this picture, both intense and more neutral, relate to the basic color family of orange.

If orange by itself were used, as shown at right, the picture would take on an oversaturated appearance. Some variety is needed. This is accomplished by using the opposite color, which is in the blue family, to neutralize some of the warmer color areas and make them cooler. An important thing to remember when selecting a color harmony is that your painting should be a personal statement of how you see a certain subject and how you feel about it.

THE DOMINANT COLOR HARMONY

One of the most basic and effective of all color arrangements is a harmony constructed on a single dominant color. This dominant color can be the local color of the subject itself, or it could come from the effect of the light. In a forest or meadow subject the green foliage and grass would certainly dominate the color harmony; in a room illuminated by a fireplace the firelight would cast a warm orange glow over the subject. Since there must be light in order to see anything, and since all light has its own particular color temperature, each subject's appearance is influenced by the color temperature of the light that illuminates it. Sometimes this influence is quite strong, as in the example of firelight, and at other times it is hardly noticed but still apparent in its effect.

Although one main color seems to dominate a subject, there is always an influence of other colors as well. At certain times of the day, a subject may be strongly saturated with a particular color while at other times it can show colors other than the dominant one. In order to achieve good color in a particular color harmony, there must be a balance between different but somewhat related colors. By starting with one main color and expanding it to bring in adjacent colors and then balancing them against neutrals and the opposite color, you can develop a harmony that has some variety and interest.

In constructing a color harmony based on one main color, there must first be a good tonal arrangement for the color harmony to be built on. Another equally important aspect of developing a successful color harmony is the use of neutral colors in the arrangement. For colors to have their most effective appearance, they must be balanced against neutral colors as well as other colors. The neutral colors act as a relief, or restful balance, for the more intense colors. The more intense or saturated a color, the larger the neutral color areas must be for proper balance. Neutral colors can be somewhat related to the dominant color by having a little of it in their mixture or they can be completely separated and stand alone. In nature, the neutral colors are more influenced by the temperature of light than the more intense colors. You can easily see this by looking at a neutral white sheet of paper in different light sources, such as daylight, fluorescent and incandescent lamplight, and candlelight.

When introducing the opposite and adjacent colors into the dominant color harmony, it is important to keep them from overpowering the original color. The opposite color acts as a balance or contrast to the main color and should never override the influence of the main color in the picture. The opposite color also helps you find some of the neutral colors needed for good balance. The neutral colors can be light or dark and still be just as effective. The dominant color harmony can be further expanded by using colors that are somewhat removed from both the adjacent and opposite colors, but make sure that they do not compete with the dominant, adjacent, or opposite colors, that their influence is even less important.

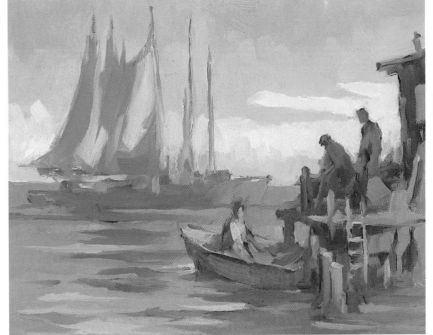

1. In this harmony, developed on a balanced tonal arrangement, the dominant color of green is balanced against neutral and less-intense colors.

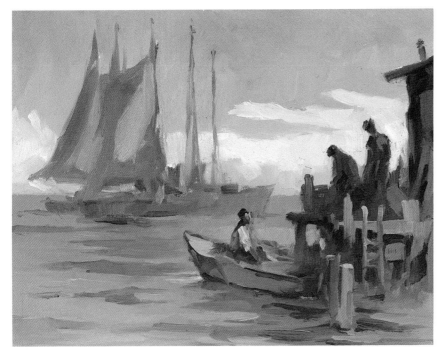

2. The next step is to balance the dominant green color and the neutrals by adding a bit of green's opposite color, red.

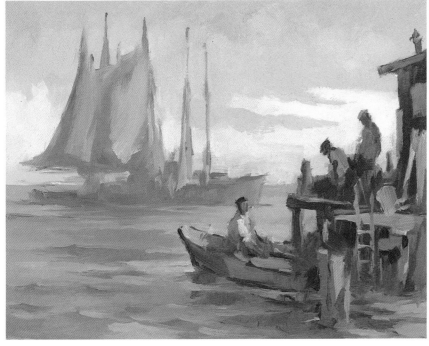

3. By bringing in green's adjacent colors, blue and yellow, an even wider range of colors becomes possible.

Using the Right Color Harmony

Although each individual subject has its own specific color harmony, how that harmony is balanced and arranged in a picture depends on the way it is seen. The same subject can impress different artists in different ways. Even though two artists paint the same subject and use basically a similar color harmony, there will still be a difference in the appearance of their work. If the artists are honest in their approach and have the skill to successfully develop their work, each painting, although different, will be a good interpretation of the subject. Even if their individual styles of painting were similar, because each artist uses color and tonal arrangements differently, their paintings would be separate and individual pieces.

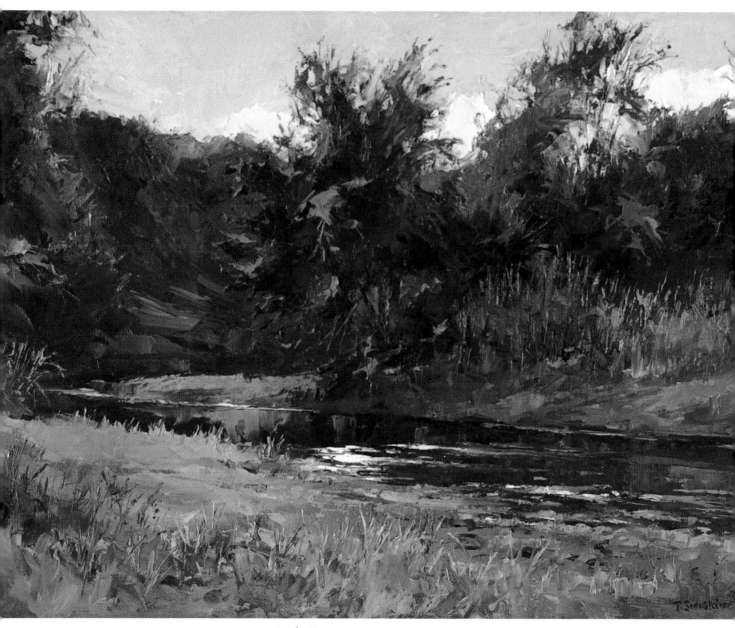

Apple Canyon, 1977. Oil, 12″ × 16″ (30.5 × 40.6 cm)

The color harmony is strongly affected by the bright yellow-green grass balanced against the much darker water, as well as the dark gray canyon wall. The thick foliage across the creek and the dark canyon wall behind are part of a strong dark tonal arrangement that extends down into the reflections in the creek. The canyon was inviting, and gave me that feeling, but yet it appeared strong and powerful too. I was able to communicate my feelings about this subject not only through the color harmony and tonal arrangement, but also in my painting technique.

BASIC PRINCIPLES OF COMPOSITION CAN BE USED FOR ANY SUBJECT.

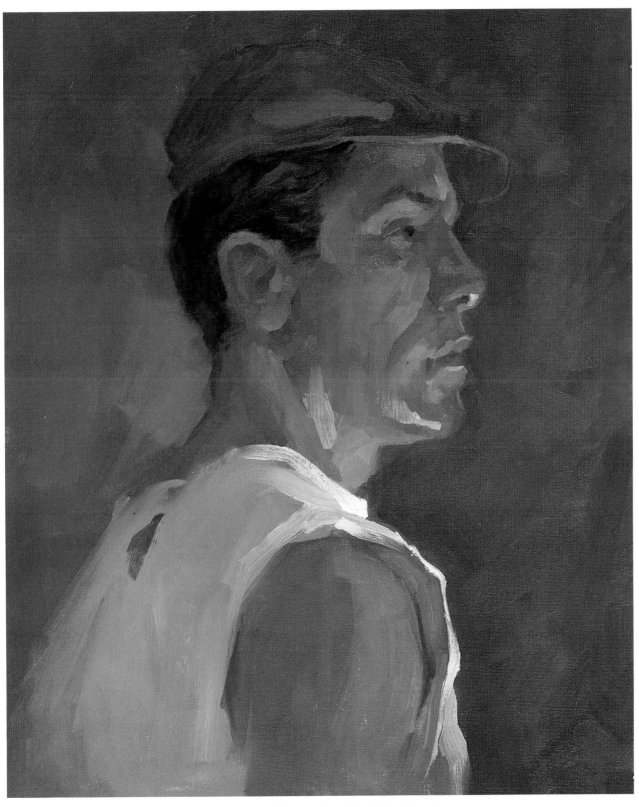

Lucian, 1985. Oil, 16″ × 20″ (40.6 × 50.8 cm)

Without light it would be impossible to see color. And because the color temperature of light strongly affects the way we see color, the color of a subject can change drastically from one time of day to another. Any change in the light temperature will alter the way color appears. But regardless of the color temperature of the light, as long as there is light enough to see, some color will be visible. This is true even at night or in a darkened room. In this painting I used a warm light placed below the subject. Notice how the use of neutral colors in the background and in the white shirt (both shadow and light) balance the smaller but more intense colors in the head.

DOING PRELIMINARY COLOR STUDIES

Since it is necessary to see color in order to fully appreciate it, any ideas of color arrangement should first be tried out in rough thumbnail color sketches before they are used in a finished painting. Thumbnail color sketches can be done directly from life as quick studies to record rapidly changing lighting effects, allowing the artist to develop knowledge and skill in observing and capturing color. Another important use of thumbnail sketches is as preliminary color studies for a finished painting, which enables the artist to explore different color harmonies and arrangements in order to select the most effective one. These preliminary sketches may also be used to try out different ideas when searching for a subject. Thumbnail color sketches accomplish one very important thing: they make it possible for the artist to almost immediately see his or her ideas in color.

Color Thumbnail Sketches

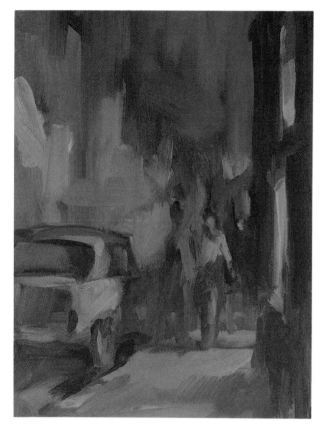

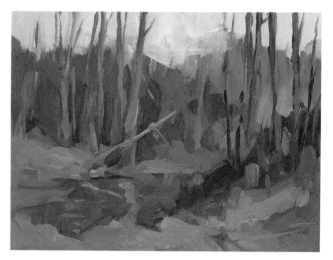

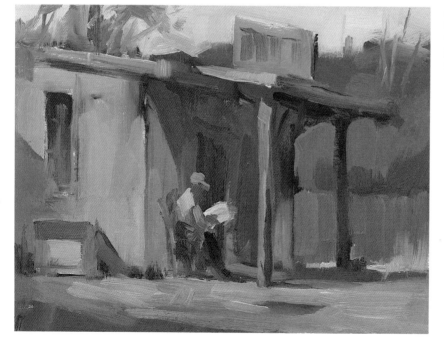

By first painting an idea as a color thumbnail sketch, I was able to visualize it in color. This was a preliminary step in the development of the painting at right.

USING COLOR STUDIES FOR FINISHED PAINTINGS

Small color studies can be used to explore different ideas for a possible painting. Many times we see a good subject for a painting for such a short time that it is not possible to do a detailed study. But we can work up a small color study from memory. Even though this small study is not a finished piece, it can have the basic qualities of a finished painting, thus guiding us toward the further development of the idea. Artists see many things and have many ideas, but until they are put into visual form, they mean nothing.

There is another benefit derived from doing small color studies. By constantly applying yourself to making these studies, you will be improving your use of color. In order to learn to use color effectively, much practice is necessary. No artist ever learned to use color just by reading about it. The only way to learn color is to use it.

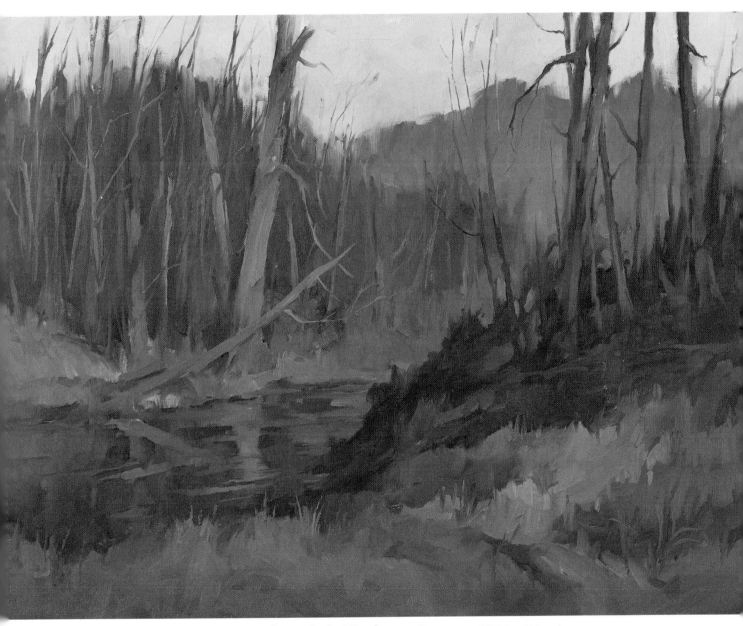

Sunset in the Woods, 1985. OIL, 18″ × 24″ (45.2 × 61.0 cm)

To emphasize the warm light of the setting sun, I balanced it against the much cooler areas of the background. The warm colors in the foreground grass and on some of the trees, as well as the larger shadow areas in the foreground, helps to set the time of day. By squinting at this painting, you can see how the darker areas pull together into strong masses. Remember that any successful effect of color depends on a good tonal arrangement.

Using Color to Express Your Feelings

The way an artist uses color can be very influential in obtaining the right feeling in a painting. Just as the tonal arrangement can be adjusted to better show exactly what the artist wanted to portray, the color balance and harmony can also be controlled to give the best possible effect. Color gives an artist such a wide range of expression that when combined with the right tonal arrangement much can be done with ordinary, everyday subjects.

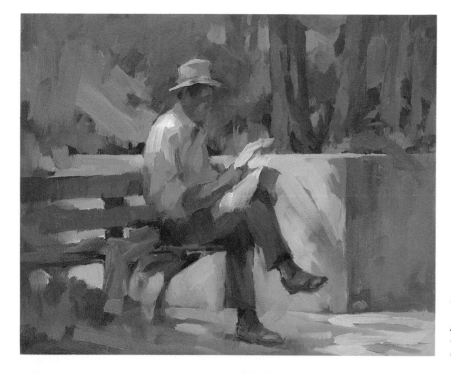

Color is very influential in helping me express my feelings for a subject. Here, I wanted to portray a quiet and restful effect but still use the broken light and dark arrangement that I had seen. To achieve this, I used colors of less intensity and weaker saturation. The influence of blue is strong in this picture. Most of the colors are not very intense, with many almost neutral colors present. The tonal arrangement has a definite separation between darker and lighter areas, with the darks dominating the picture. However the darks are of a close tonal range with very little contrast.

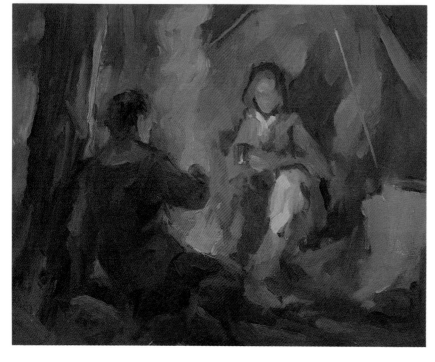

In order to achieve the more dynamic effect in this picture, I used a color harmony strongly saturated with orange. Some of the warmer colors are very intense and there is a strong temperature contrast between the light and shadow areas. The darks dominate the picture area, with sharp contrast between the smaller lights. Notice the important influence of line as well as how the use of mass helps give unity to the composition. There is a strong and rich effect of color in the darks. All this color and tonal contrast helps give this picture a vibrant and dynamic appearance.

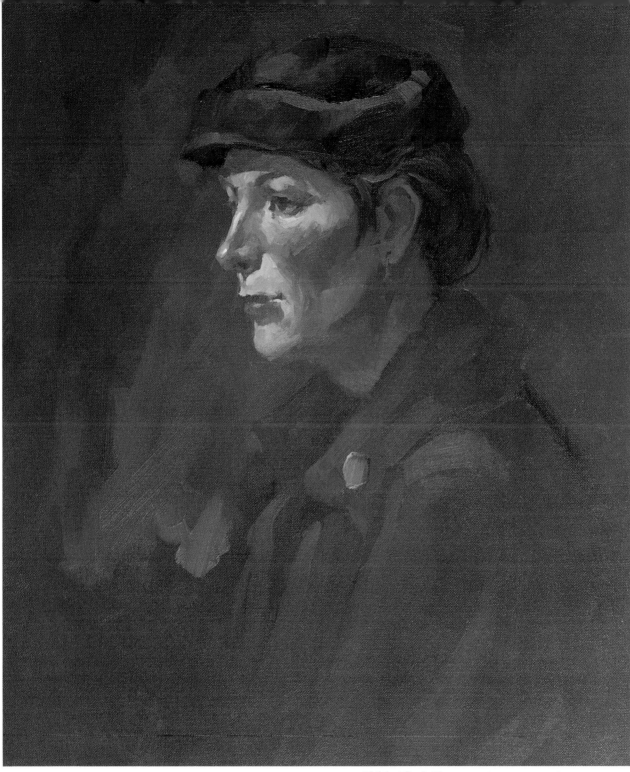

Girl in Black Hat, 1985. OIL, 20″ × 24″ (50.8 × 61.0 cm)

THE IMPORTANCE OF COLOR STUDIES FROM LIFE

It is best to learn to see and use color by making direct studies from life. In the beginning the studies can be rendered from a model or a still life illuminated with a fixed and steady light. For these studies the light source can be either artificial light or natural daylight coming in through a window or skylight. Each light source has its advantages as well as its disadvantages. Natural daylight shows a wide variety of subtle color variations, however it is not a steady light and it can change throughout the day.

Artificial light, although of a steady and unchanging nature, may oversaturate the subject with its color temperature and at times may make some colors appear too strong. The best approach is to take advantage of all their best qualities by using natural daylight sometimes and artificial light at other times. Through continual work from life, the artist develops the ability to accurately see and compare color. Learning to see color is an important first step in successfully using it.

Chapter Seven
EXPRESSIVE TECHNIQUES OF OIL PAINTING

An expressive painting begins with a good idea, developed with good composition and effective use of color. In this chapter, we will discuss the different methods of building up a painting as well as how to paint in order to achieve maximum effect and permanence. It is easy for the artist to become involved in clever ways of paint application and completely ignore sound techniques of oil painting. Poor painting procedures can lead to all kinds of problems later on with possible cracking, flaking, and changing of color in the finished painting.

> **INDIVIDUAL CREATIVE EXPRESSION MUST BE CONSTRUCTED ON GOOD COMPOSITION AND EFFECTIVE USE OF COLOR.**

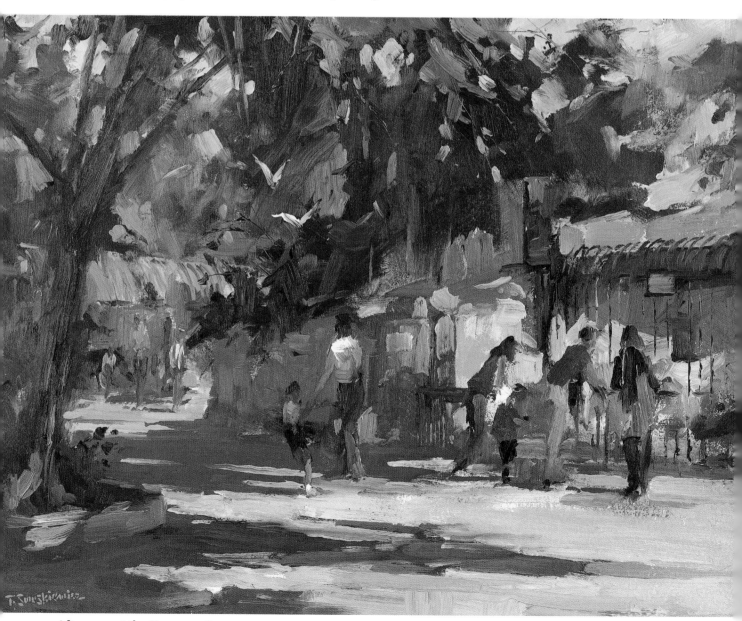

Afternoon at the Zoo, 1975. OIL, 12″ × 16″ (30.5 × 40.6 cm)

SOUND PAINTING TECHNIQUE IS IMPORTANT

Because of its own particular makeup, oil paint requires certain sound painting techniques for maximum permanence. The vehicle in oil paint that holds the pigment particles together upon drying is linseed oil. When this oil dries, it forms a tough and durable paint film, and with a light protective coat of varnish it will retain its color for a long time. Linseed oil dries by oxydation, not evaporation. This means that as the oil dries, it combines with oxygen, which changes the physical makeup of the paint itself. Oil paint with an excessive amount of oil can actually expand upon drying. Because of this, paint must be applied in certain correct ways.

There are two basic ways of applying oil paint: *direct* and *indirect*. In direct painting, the artist visualizes and builds the painting up for the finished effect from the very beginning, with the first use of line, tone, and color. In this approach, the painting is usually finished in a relatively short time, anywhere from one day to several days. The paint never really dries very much between painting sessions, so overpainting does not present much of a problem.

Using oil paint with a painting medium gives longer, more fluid brushstrokes with some almost-transparent effects.

Using oil paint without a painting medium gives a more textured appearance and much shorter brushstrokes with broken edges.

The direct approach is often used when working from life, especially in outdoor color sketching.

In the indirect method of painting, the beginning of the painting is not visualized as the final effect. The first stages of work are considered an underpainting that will be modified and improved with overpainting until it has the effect that the artist desires. This approach takes longer, especially if glazing is involved. Glazing is the painting of transparent color over another color with an oil-varnish glazing medium so that both colors combine visually to give the right color. For instance, if a yellow glaze is laid over a blue color the resulting color will be in the green family. When building a painting up with oil glazes, you must allow time for the glazes to dry before applying new glazes over them. Whether the colors are transparent glazes or opaque layers of oil paint, this basic rule of applying oil colors must be followed: colors with more oil, that are slower drying, should be applied over colors with less oil that are faster drying.

USING A PAINTING MEDIUM

Oil paint, because of its thick, almost butterlike consistency, gives good brush effects and surface texture. However, in order to obtain a fuller expression, the working consistency of the paint must be changed by using a painting medium. The simplest of all painting mediums is just pure gum spirits of turpentine or mineral spirits. Both of them dilute the paint into almost-transparent washes that dry somewhat rapidly. For this reason they are excellent for preliminary drawing with paint and for tonal underpainting. When using more opaque paint and when applying it in a heavier manner, add a little linseed oil to the turpentine or mineral spirits. A good ratio is ¼ artist-grade refined linseed oil to ¾ turpentine or mineral spirits. Using excessive linseed oil with the paint will adversely affect its permanence, and never use pure linseed oil by itself as a painting medium. Correctly used, a painting medium enables the artist to enlarge his or her expression with long, fluid brushstrokes or transparent washes that produce subtle variations of color.

Another use of painting medium is to "bring-up" sunken or dull areas of the painting before overpainting them. In this case add a little Damar varnish to the painting medium and apply a little of this varnish-and-oil mixture to the sunken or dull painted surfaces. Wipe off any excess. This will also give the painting an almost-wet surface that will help considerably in softening and losing edges.

Painting Materials and Their Use

Oil painting requires certain tools. Besides the colors themselves, you will need bristle brushes and painting knives to apply the paint, stretched canvas or painting panels, and some type of easel. A palette—made of wood, glass, or some other smooth and sturdy material, such as hardboard that has been treated with linseed oil to make it nonabsorbent—is also necessary. Turpentine or mineral spirits, oil cups for holding them, and rags or paper towels for wiping hands and brushes are additional necessary painting materials.

OIL COLORS. Oil colors are made by grinding color pigments together with refined linseed oil until the right consistency is achieved. Since each color pigment absorbs oil differently, some needing more than others, each oil color has its own oil-to-pigment ratio.

The pigment used in oil colors comes from different sources and is made of a wide variety of chemical compounds that are relatively stable.

When selecting oil colors for your palette choose more than one of each primary hue. A good basic color palette (not necessarily all at the same time) is as follows: in the yellow family, cadmium yellow light, cadmium yellow pale, and yellow ochre; in the red family, cadmium red light, alizarin crimson, terra rosa, indian red, and burnt sienna; in the blue family, viridian, cobalt blue, cerulean blue, ultramarine blue deep, and ivory black. Avoid the extremely strong phthalocyanine pigments. They are difficult to control and have a tendency to oversaturate color mixtures. A good basic white is titanium white.

BRUSHES AND PAINTING KNIVES. Bristle brushes are firm enough to allow the artist to use the thick consistency of oil paint to the best advantage. There are four basic brush styles, each of which comes in many different sizes: *flat, bright, filbert,* and *round.* A good all-purpose brush is the flat, which charges well with paint and produces a variety of different effects. When purchasing bristle brushes be sure to select well-made brushes. A good bristle brush will give years of excellent service if it is not abused and if it is cleaned well with soap and water after use.

Painting knives are made of tempered steel and are generally triangular in shape. They are very flexible and can be used to apply oil paint in a variety of ways from broad and flat applications of paint to very thin and narrow strokes. The trowel-shaped ones are the best, as their shape provides room for your fingers to clear the wet surface of the painting.

CANVAS AND PAINTING PANELS. The most usual surface that is used to paint on with oil colors is canvas, either stretched over a frame or in the form of a panel. Any surface that is used with oil colors must first be coated with nonabsorbent priming called a *ground.*

There are two basic kinds of canvas used for oil painting, linen and cotton, available in many different weights and surfaces. Linen is the more permanent and stronger surface. Canvas usually comes in six-yard rolls but can also be purchased by the yard. To receive the full benefit of working on canvas, it should be stretched over a frame of stretcher bars. Canvas can also be purchased pre-stretched in standard sizes and limited surfaces.

Panels also make excellent surfaces to work on and they can easily be made by cutting some untempered hardboard to size and then painting it with several coats of acrylic gesso. If a more textured surface is desired, glue unprimed raw canvas to the hardboard surface with animal glue or contact cement, and after the glue is dry apply two coats of gesso ground. You can also stretch raw unprimed canvas and prime it directly with an acrylic gesso ground. If an oil paint ground, such as white lead, is desired then the canvas must first be sized with rabbitskin glue.

USING COLORS AND A PALETTE

The palette not only provides a place for mixing color but it can also help the artist to correctly judge the color of a painting. As the painting develops, the color mixtures on the palette develop in a similar way. Place your colors on the palette as shown here, with white in one corner and the colors divided into two groups: warm and cool. Mix across the palette with warm and cool colors to get color mixtures that are not "muddy" and overmixed. Restrict yourself to two or three colors for cleaner mixtures.

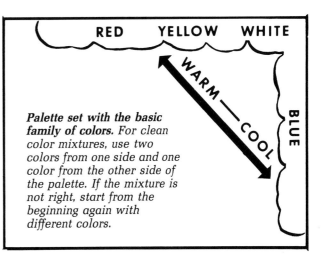

Palette set with the basic family of colors. For clean color mixtures, use two colors from one side and one color from the other side of the palette. If the mixture is not right, start from the beginning again with different colors.

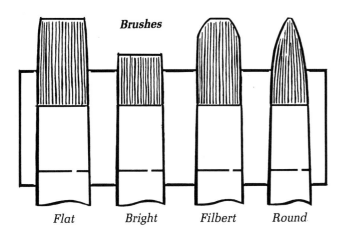

Brushes

Flat *Bright* *Filbert* *Round*

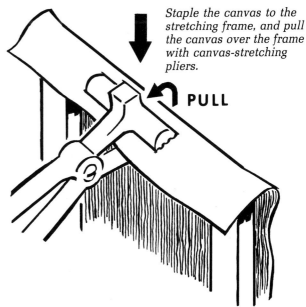

Staple the canvas to the stretching frame, and pull the canvas over the frame with canvas-stretching pliers.

PULL

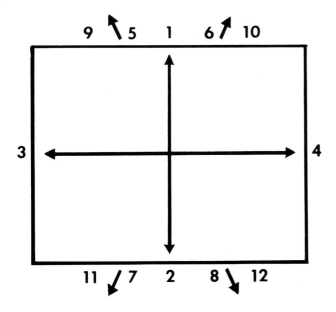

STRETCHING A CANVAS

First assemble the stretcher bars by firmly pushing the corners together until they are flush. Check the squareness of the assembled frame with a carpenter's square. Laying the stretching frame on canvas, cut the canvas to size, allowing about 2" extra width on all four sides. Fold over on one side and staple it with a staple gun. Using stretching pliers, pull the canvas with an even but firm pressure until it is somewhat taut. Staple opposite sides of the frame, in order, and from the center out. When you reach the corners, fold them over and staple them. Do not cut the extra canvas that extends over the frame but fold it back also and staple it.

Three Basic Ways of Starting a Painting

There are three basic ways of starting a painting, which may be used individually or in combination. The first and most common is with a *line drawing.* This gives the artist complete control in placing and showing all the individual forms and parts of a subject. It can also restrict the development of the painting if the drawing is too detailed and intricate. Many artists use line only to indicate the larger forms and tonal areas, which serve as a guideline to the further development of the darker tones and the addition of the color areas.

The second basic way of starting a painting is with *tone.* In this approach, the artist does not become involved with details in the early stages, which has the advantage of giving the painting a much more solid start. Masses of similar tones pull the picture's many different parts together into simple and more solid units, enabling the artist to easily visualize the finished effect. A sure and rapid way of painting a tonal block-in is to use an oil wash. No white is used and the colors are diluted with turpentine or mineral spirits and applied in a transparent way.

A somewhat neutral color mixture is rubbed over the whole surface and the major light areas are lifted out with a rag dampened in the paint thinner. Appropriate edges are put in and hardened or softened where necessary.

The third basic way of starting a painting is with the *direct use of color.* In this approach, the artist thinks in the beginning stages primarily of color, with satisfactory color harmony and arrangement taking precedence over any consideration of form. As the colors are developed, a tonal arrangement will begin to emerge and the artist can give some attention to developing edges and other necessary details to find form. Care must be taken at this time to avoid losing the simplicity and effectiveness of the first color block-in arrangement.

There is not just one right way to start a painting, there are several. Each of them, or some combination of them, may be best for you, depending on what you see and feel about a subject. Always be honest with yourself and choose the most effective approach that your skill and experience will allow.

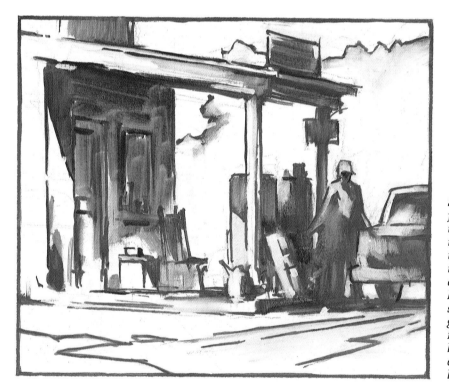

Starting with line. Indicate the major forms and dark tonal areas with line using an appropriate color diluted in turpentine or mineral spirits. Some of the stronger darks can be worked in to help obtain a better representation of form. The line drawing should be kept as simple as possible but yet as strong as necessary to give adequate guidance. Avoid detail. Paint colors in where the lines indicate they belong and then compare them against each other for the correct balance.

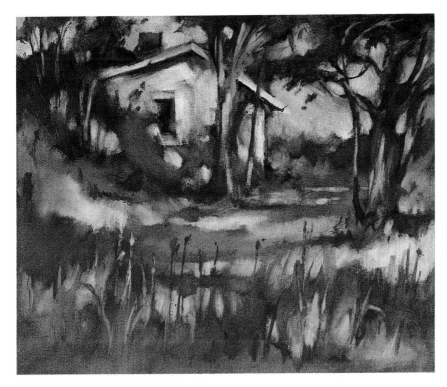

Starting with tone. First rub a color compatible with the subject's main colors over the entire surface of the painting. Dilute it with turpentine or mineral spirits and apply it in a middle tone value. Lighten or lift out the main light areas of the composition with a rag dampened in the paint thinner. Brush on some diluted color to darken lighter areas again as well as some of the other tonal areas. Define edges where necessary and remember not to use any white. Do not develop this underpainting in too much detail.

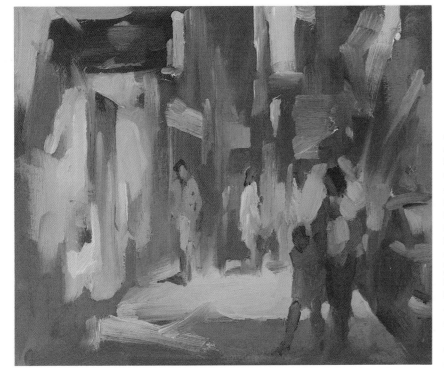

Starting with color. Plan your color harmony beforehand and mix the colors to be used. Use as many colors as necessary and paint them in boldly. Avoid thinking about individual forms at this time; concentrate only on obtaining a satisfactory balance of color in the picture. When painting in the colors, some consideration should also be given to a tonal arrangement for the picture. As soon as a satisfactory tonal and color arrangement is obtained, edges and other details can be worked in to bring out more of the form. Be careful not to lose the simplicity and effectiveness of the first color block-in arrangement.

Using the Tonal Approach

The tonal approach can be used for almost any subject. It is especially useful in clearly visualizing the subject's form at the earliest possible time. With a well-balanced and effective tonal arrangement to build on, the painting can be easily developed in color. It is important not to develop the tonal underpainting in too much detail and finish, as you may feel restricted when you attempt to overpaint.

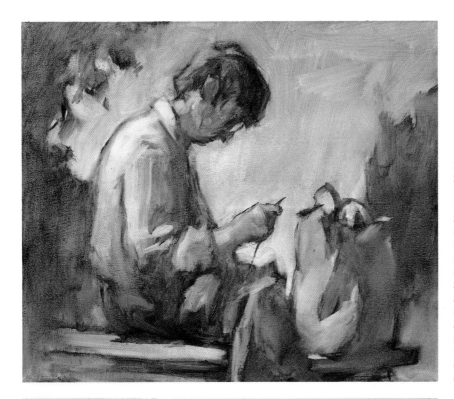

1. In this tonal underpainting, terra rosa and viridian green were used to block in the composition. The colors were diluted with turpentine and rubbed in over the picture surface, and the lighter areas were lifted out, down to the white surface, with a turpentine-dampened rag. Some diluted viridian green was brushed into the background and some terra rosa was worked into the face, hands, and bag. Finally, edges were made stronger where necessary to help define the form. Using two colors, warm and cool, in the underpainting can be an effective way to obtain a direct start.

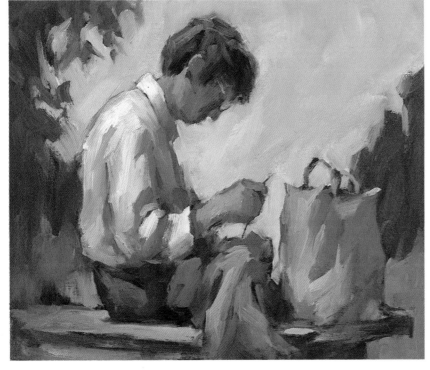

2. The more opaque colors of the final painting were painted directly over the underpainting. The two colors used in the underpainting influenced my choice of colors in the overpainting: terra rosa, viridian green, cadmium yellow pale, cadmium red medium, cobalt blue, and titanium white. The use of thicker and more opaque paint enabled brush effects to be used in developing the different forms of this subject. Although a transparent tonal underpainting in two colors can be impressive, remember that oil color is basically an opaque painting medium and its best effects always come out when it is used as such.

Using the Color Approach

The direct use of color is a rapid way of working and is suitable for sketching or working outside in rapidly changing light conditions. Another important use of this approach is in developing ideas from your imagination and in working out color harmony arrangements. When starting a painting with this method, first select some colors as a simple palette and then decide on some type of color harmony for your painting. Apply the colors freely and try not to think of form. Take advantage of any interesting tonal arrangement that may appear and use it to strengthen the work.

1. Using a palette of cadmium yellow pale, yellow ochre, cadmium red medium, terra rosa, and cobalt, I brushed in the basic colors of this picture as I visualized them. But before starting, I had an idea of a certain type of light effect that I wanted: a pattern of sunlight coming into a shaded area under some trees. The subject arrangement was not known at this time so I did not think of form until I began to see the light effect emerging. At that time some edges were made stronger and the steps and railing began to come out.

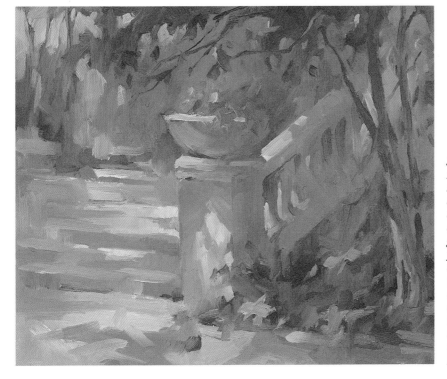

2. Working into the painting further, more definition was developed in the steps, the railing, and the trees. I was careful to retain the original light effect. The direct use of color in developing a painting can give it a great deal of spontaneity and freshness. It enables the artist to develop imaginative ideas and to work from memory. Remember to use as few colors as possible and to take advantage of tonal arrangements as they develop. Working directly in color allows the full use of feeling and emotion in the development of an idea.

Using a Brush for the Best Effect

The thick consistency of oil paint allows brushstrokes to be laid in that give texture and expression to certain areas. Using a painting medium changes the character of the brushstroke, producing a softer and more fluid effect. Different styles of paintbrush give different types of brushstrokes and affect the way the paint is applied. By taking advantage of the many different ways of using a brush, you can increase your painting vocabulary and become more expressive. You can also combine several ways of using a brush. However, remember that the subject and its over-all effect is what should finally determine how you should use a brush in painting.

In this painting, I used a brush not only to develop the individual forms of the model and her clothing, but also to express the character and effect of this subject. The color harmony is basically in the blue family, with the adjacent colors of red and violet and the opposite color of orange. Notice how the brushwork gives direction and helps lead the viewer's eye.

The Lady in Blue, 1985. Oil, 20″ × 24″ (50.8 × 61.0 cm)

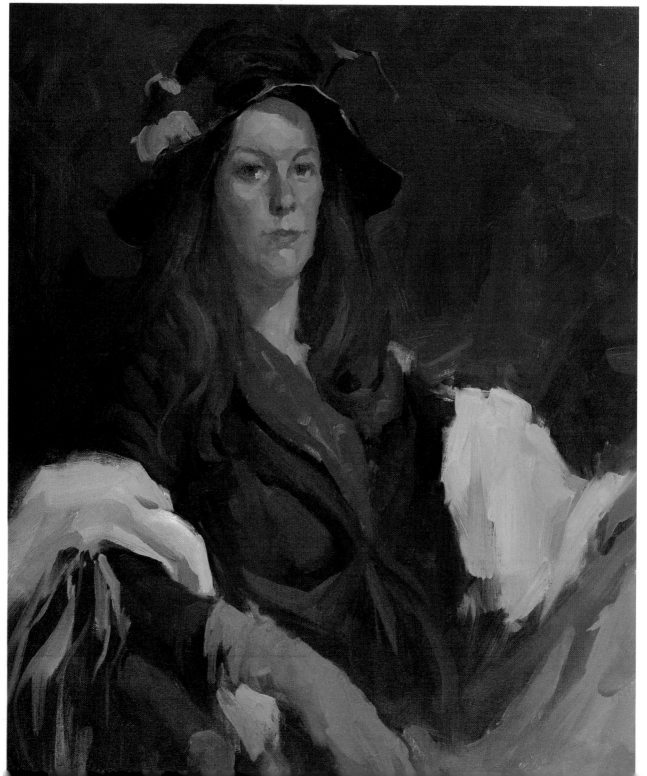

In painting this subject's hair, I used flat brushes that were well charged with oil paint. After I picked up the right color mixture with my brush, I dipped it into a little painting medium to obtain longer and more fluid brushstrokes. Color was worked into color with definite brushstrokes and I was careful to wipe the brushes in a rag after several strokes or when changing color. Some good effects in painting hair can be achieved by painting wet-into-wet. In this approach, soft and lost edges are easy to obtain. The form of the face was blocked in with definite brushwork but without the use of a painting medium. If excess paint builds up on the surface, scrape it off with a palette knife before painting into it again. Working wet-into-wet requires certain procedures like wiping out your brushes and scraping off excessive paint in order to successfully apply your colors.

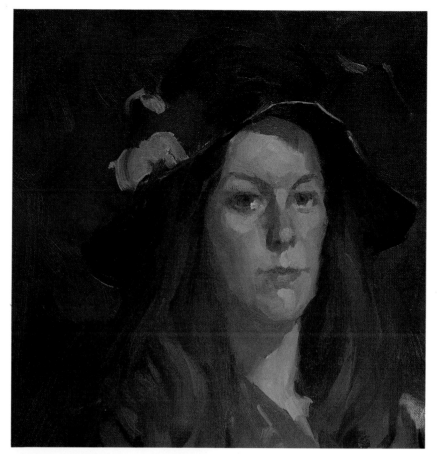

In painting this section of the picture, the basic tonal arrangement was first blocked in with some of the colors. Some painting medium was used at this time. With this first painting block-in still wet, I brushed in some of the folds and other forms of the clothing using a flat bristle brush well charged with paint. Sometimes the color changed as the brushstrokes began to develop the form, as in the pink glove and the white shawl over the arm. While painting, I wiped my brushes frequently with a rag to prevent the color from becoming muddy looking. I also tried to restrict myself to as few brushstrokes as possible and avoided overblending the colors.

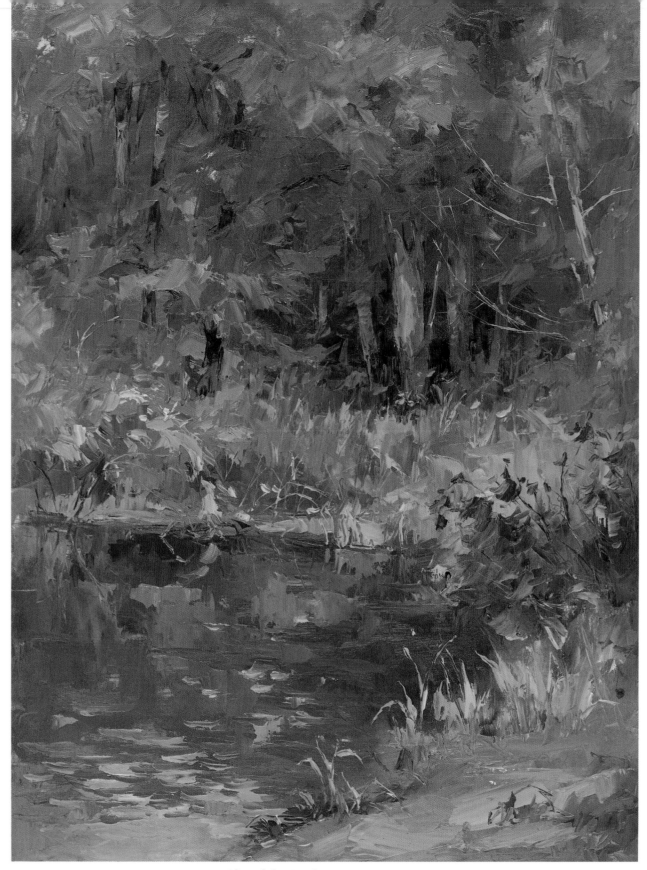

Edge of the Pond, 1978. OIL, 12″ × 16″ (30.5 × 40.6 cm)

In starting this painting, I first rubbed some color into the surface with a rag dipped in turpentine in order to develop the basic tonal structure. Using a triangular-shaped painting knife, 1½″ in length, I mixed colors on the palette and applied them to the painting. Painting with a knife produces a certain crispness and freshness, which, however, may be softened and subdued in areas where needed. Colors applied with a knife are fresh and clean in appearance because their surface is not broken down by the many small grooves and marks of a bristle brush.

Using a Knife for the Best Effect

In order to obtain the effect that I wanted in this section, I first worked color into the surface somewhat flatly and without definite edges or boundaries. This was done by scraping off the excess paint and sliding the knife, held flat against the surface, across the areas of color change. The color was matched to the first and more neutral tone that was rubbed in with a rag. Mixing the right colors, I applied them with a painting knife in such a way that form began to develop along the shoreline. Whenever the color seemed to be wrong, I scraped it off and applied a new color. When using a painting knife, many interesting effects are possible, and the artist should always be ready to take advantage of them.

There are two basic ways of applying paint with a painting knife. It can be applied in broad, flat strokes using the flat undersurface of the knife as shown in Figure 1. This gives larger flat areas of paint, as can be seen in the closeup on the right. If the knife is held on end, so that only an edge touches the surface, as shown in Figure 2, then by pulling it back, a narrow line of color is deposited. When using a painting knife it is not necessary to pile on paint as if you were plastering a wall. Sometimes just a few good colors worked into the picture's surface with several strong accents is enough.

Combining Different Painting Methods

There are times when an interesting subject owes its appearance to its combined construction of line, tone, and color. Then the artist must decide on how to combine the different approaches to painting in order to capture these different influences. Using a painting knife as well as a brush and starting a painting with a strong color approach could be necessary for certain subjects. Taking advantage of the qualities of wet-into-wet painting at the very beginning is another direction that the artist may choose in order to show the subject in the most effective way. Whatever method of starting and developing your painting you select, allow your subject and its effect on you to determine how you will finally paint it.

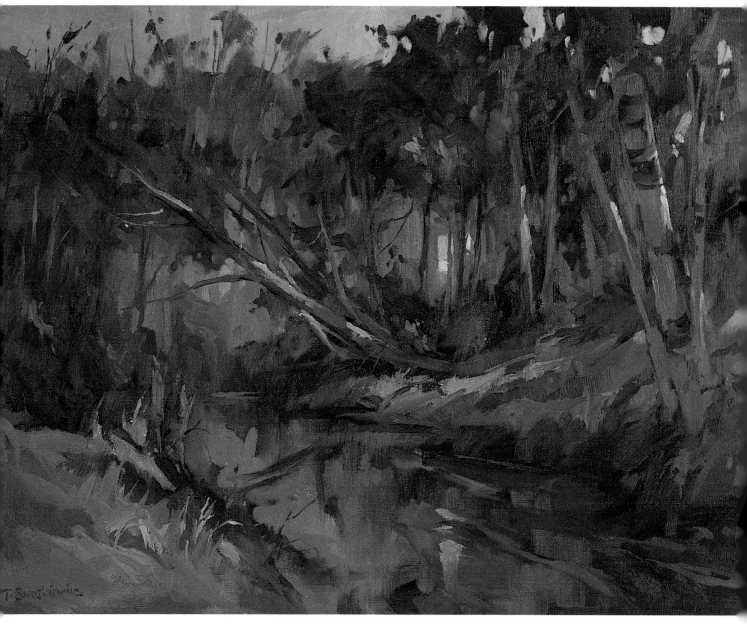

Stream at Night, 1984. OIL, 18″ × 24″ (45.2 × 61.0 cm)

In this painting of an autumn night scene, I combined several approaches in order to achieve the effect I wanted. Seeing that this subject called for a darker tonal arrangement and also a certain richness of color, I started this painting with tone as well as color. The individual forms were not brought out until a good foundation in tone and color was developed. Although I used brushes most of the time to paint in the individual forms of the trees and water, I also used a painting knife to put in certain passages. Several of the basic colors, such as in the sky, the background, the foreground, and the water, were established at the beginning of the painting and were used to help balance other parts of the painting later on.

PAINTING EXERCISES WITH BRUSH AND KNIFE

These exercises are basically designed to help you develop control in wet-into-wet brush and knife handling. When painting in this way, always have a rag or absorbent paper towels handy, and wipe your brushes and knives frequently while using them. This will help to keep your colors clean while painting.

1. Using a bristle brush, paint a dark color evenly over a 3" square. With a lighter color of a related hue, paint into the darker square while it is wet and develop some types of form. Do not try to overblend your painting; leave your brushstrokes alone.

2. Paint a darker color into a wet and lighter related color and develop some definite forms. Remember to wipe your brush out in a rag frequently when painting wet-into-wet.

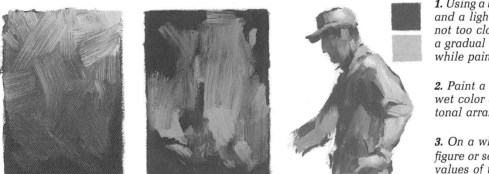

1. Using a bristle brush, paint a darker and a lighter color together that are not too closely related. Try to obtain a gradual blending with brushstrokes while painting wet-into-wet.

2. Paint a lighter color into a darker wet color and develop a balanced tonal arrangement.

3. On a white dry surface, paint a figure or some other form in two tonal values of the same color. Use brushstrokes to build up the form.

1. Using a painting knife, paint a darker and lighter color together, trying to achieve a gradual blending of tone. Try not to overblend the knife strokes.

2. On a white dry surface, paint a thumbnail color sketch with a painting knife. Use a limited palette of no more than four colors. While painting, be sure to wipe your knife off frequently.

Using the Right Technique for Effect

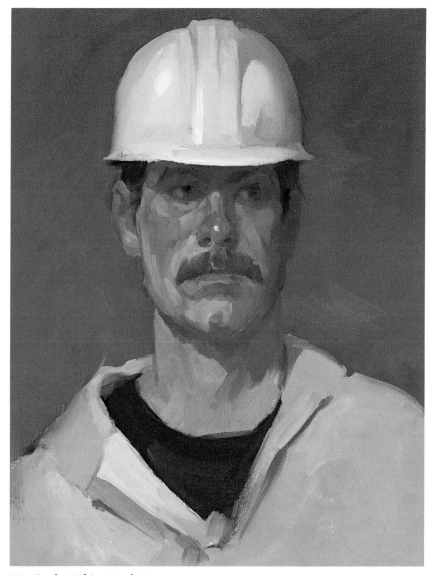

Man in the White Hard Hat, 1984. OIL, 16″ × 20″ (40.6 × 50.8 cm)

Since there are several good ways of starting and developing a painting, careful thought should always be given to choosing the best way for a particular subject. Sometimes, as in this painting, a solid line and tone approach is necessary. I applied my colors directly and boldly with a brush over a line and tone block-in, being careful not to lose the individual strokes. Notice how the strong modeling of the features balances against the smoother and more rounded form of the hard hat. The neutral colors of the hard hat and shirt create a good balance for the intense colors in the face.

The finish of a painting begins with the first brushstroke. How you start your painting will determine how you will develop it to its finish.

The Trading Floor, 1984. OIL, 20″ × 24″ (50.8 × 61.0 cm)

In painting this picture, I used a direct tonal and color approach. This composition was developed from direct observation and sketching on the trading floor of the Mercantile Exchange. I wanted to show the activity and commotion on the trading floor, so I first worked in a tonal arrangement of several colors, without indicating any of the figures. I was just trying to obtain a strong feeling of the apparent confusion. Then I developed the individual figures and other forms directly out of the first block-in of color. The whole painting was done with brushes, and some painting medium was used in the beginning stages to obtain more fluid brushstrokes.

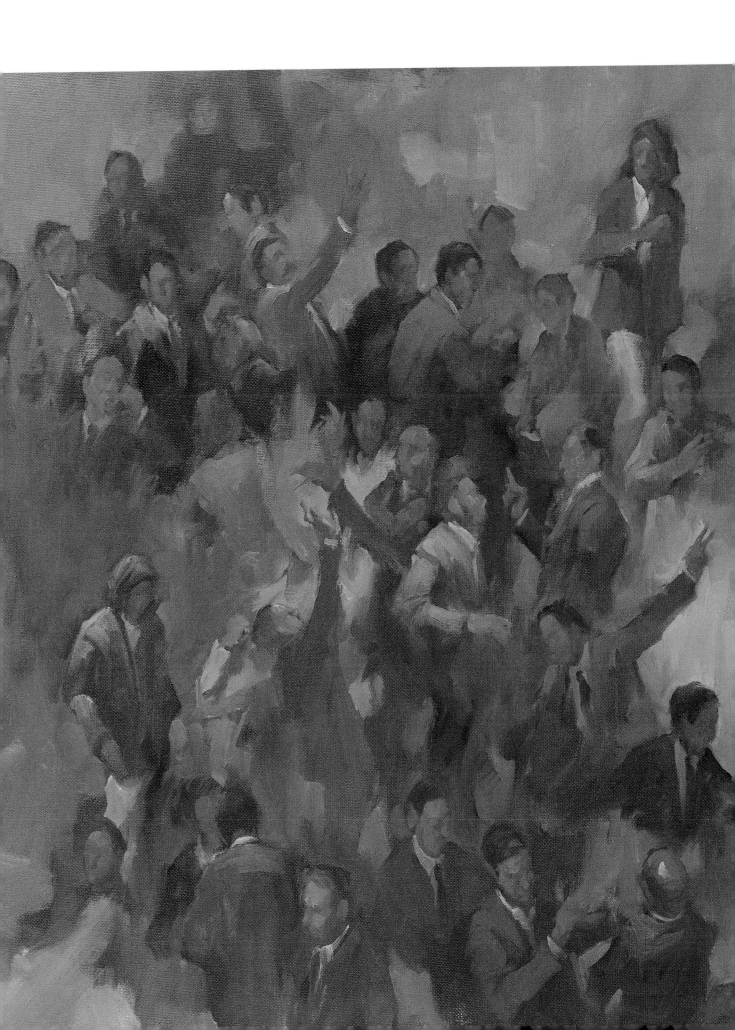

Chapter Eight
PAINTING OUTDOORS

Of all the subjects that an artist has available to work from, painting outdoors directly from life can be the most rewarding. Compared with indoor studio painting, working outside exposes the artist to a wider range of color and light effects because of the changing light and atmospheric conditions. What may look uninteresting in the morning can take on an exciting new appearance later in the day. Painting outdoors enables the artist to experience the dimension of depth in a picture. This is true because only in the distances of outdoors can the principles of linear and atmospheric perspective be fully used.

Atmospheric perspective allows the artist to introduce changes of color as the subject recedes into the background. As things go back into the distance, a curtain of atmosphere builds up between those things and the viewer. Colors and tonal values begin to change, sometimes, especially in certain weather conditions, quite dramatically. It is only through direct study of these different conditions outdoors that the artist will become proficient and successful in capturing them.

The Bird Bath, 1985. OIL, 12″ × 16″ (30.5 × 40.6 cm)

I painted this bird bath one summer afternoon in my backyard. An ordinary outdoor subject like this can take on a beautiful appearance if the light is just right. Notice how I arranged the dark and light composition. I used brushes freely, with a little painting medium. Excessive detail was avoided in the foliage. Some atmospheric perspective was used in the background to help give the painting distance.

The Asphalt Yard, 1985. Oil, 12″ × 16″ (30.5 × 40.6 cm)

There are many interesting and different outdoor subjects to paint. I found this asphalt yard one Sunday morning while out sketching. The emptiness and lack of activity in the yard impressed me and I recognized it as a good subject. It was a hazy, sunny morning with definite shadow darks. I used strong linear construction as well as mass or tonal painting in starting this picture and I applied my colors freely using a flat brush. Notice the definite but simple brushwork used in the yellow-orange vehicle on the right. The angle at which it is parked helps to balance the vertical and even construction lines of the background buildings.

THUMBNAIL SKETCH STUDIES. Small color thumbnail sketches are an excellent way of painting outdoors with minimum equipment. They can be painted on panels using only a paintbox. This will be explained more fully on the next two pages. By using only the basic tonal and color construction features of a subject, complete and effective sketch studies can be made quickly. The thumbnail sketch on the right is constructed on a strong dark mass that holds together and dominates the picture. Neutral and less-intense colors are an important part of this color harmony and balance. Notice how much smaller the stronger intense colors are in relation to the larger and more neutral colors. This is an important principle of color balance.

Outdoor Painting Equipment

Painting equipment used for outdoor work can be very elaborate or it can be minimal. A lot of fancy equipment does not necessarily improve the painting. If you keep in mind the main purpose of painting outdoors, your equipment can be selected for effectiveness and portability. It is best for the beginning outdoor painter to work on smaller sizes and to concentrate on quickly rendered thumbnail sketches or studies, so the less equipment the better.

A basic piece of equipment is the ordinary wooden 12″ × 16″ paintbox. This is also known as a sketchbox because of its enclosed palette and slots in the lid that will hold two or three painting panels. There are compartments in the box that will hold tubes of paint and brushes. The wet palette sits face-up on top of these compartments and covers them securely, being held in place by the closed lid. The lid locks in an open position, turning it into a convenient easel. The closed box is easy to carry and contains all the basic equipment for painting outdoors.

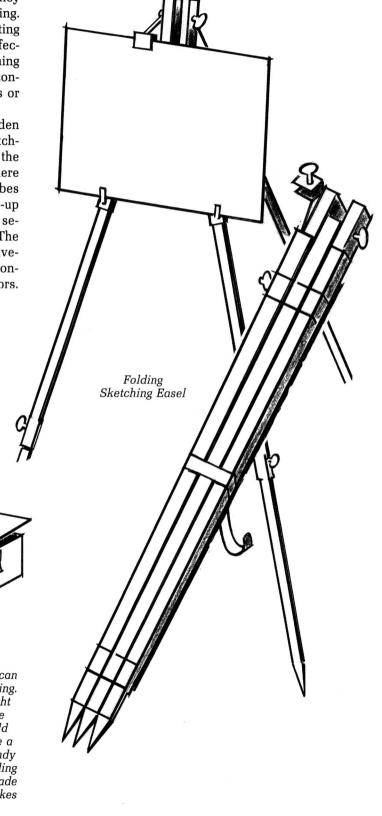

Folding Sketching Easel

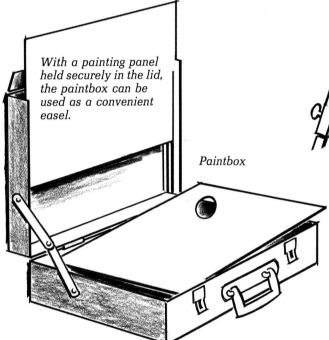

With a painting panel held securely in the lid, the paintbox can be used as a convenient easel.

Paintbox

If you sit on a small, folding campstool, the paintbox can be held on the knees and easily used directly for painting. Painting from a standing position requires a lightweight but sturdy tripod-type sketching easel. In this case the palette is held on the arm, using the thumbhole to hold it securely. Some of the aluminum folding easels have a stabilizing bracket between the legs that makes a handy platform for supporting a paintbox and palette. The folding tripod easel used for outdoor painting should be well-made and not wobble when set up. The legs should have spikes that will permit solid anchorage in the ground. This outdoor painting outfit is lightweight and easy to carry. Some other useful things are extra paint rags, a sketchbook, a waterproof poncho, and a snack or light lunch, all of which can be carried in a tote bag.

Painting with the paintbox

Using the paintbox as an easel can reduce the amount of equipment necessary for outdoor work. Since it can hold up to three painting panels, a palette, tubes of paint, and brushes, the only other equipment you would have to carry would be a small folding campstool on which to sit. Just place the box on your knees while sitting and proceed to paint on a panel held in the open lid. Use the palette in the box to mix your colors on. An adjustable belt or strap looped around your waist and attached to the box with some sort of fasteners will prevent the paintbox from sliding off your knees.

*Painting with an easel
and using an arm palette*

To use an arm palette, insert your thumb into the thumbhole and balance the palette on your arm. An extra brush and wiping rag may be held in the same hand for convenient use.

USING AN ARM PALETTE. Using an arm palette enables the outdoor painter to step back and judge the painting and at the same time to mix colors on the palette. This allows you to see your painting as a complete unit and to more easily compare its many different parts. You can judge colors more accurately when you can step back with your palette. Also, you can hold the palette in such a way that direct sunlight is prevented from striking the mixing surface. Since it is very difficult to correctly judge your colors in direct sunlight, position your easel so that the painting is in shadow. Sunglasses distort a painter's color sense, so wear a hat with a brim or visor to shade your eyes from the sun.

Outdoor Painting Procedure

When first beginning to paint outdoors, it is easy to be overwhelmed by the many different things that you can see in any particular view. To help you select and more easily visualize your subject, use a view-finder or some other type of framing device. Before starting your painting, make sure you have studied your subject closely from several different viewing positions in order to select the best one. Be sure to squint so that the dark and light arrangement can be clearly seen.

Although any or a combination of all the basic approaches to starting a painting (line, tone, and color) can be used in outdoor work, it is probably better to concentrate on establishing the tonal arrangement first. First rub an almost-neutral color of a middle tone value over the entire surface. Indicate the main dark and light areas with a brush, then clean out the lights by wiping them with a rag dampened with a paint thinner. The darker tones can then be put in.

There are certain subjects or lighting conditions that require the direct use of color. First, roughly indicate some of the basic picture arrangement and then apply the colors directly as you see them.

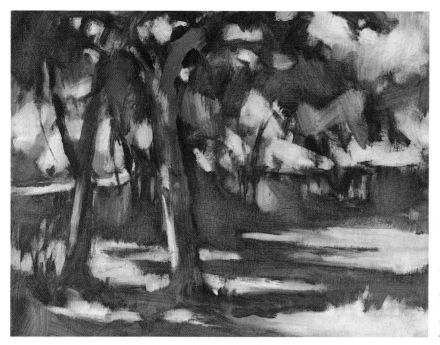

1. Use a color compatible with the subject's final color harmony for the tonal block-in. Thin the color with turpentine or mineral spirits and use it in a transparent manner by avoiding white. The tonal approach to starting a painting outdoors is especially useful on a sunny day when shadow and other dark patterns can change significantly in an hour.

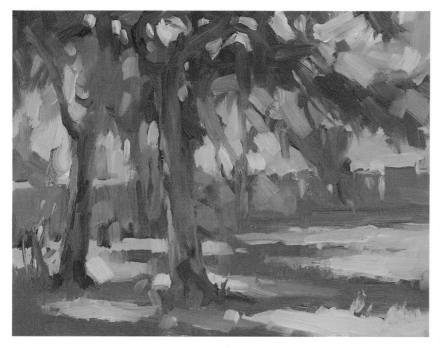

2. The correct use of color depends on a good tonal foundation and a clear understanding of the temperature of the main light source. Colors are mixed and applied directly over the right tonal area. In this way the color block-in can be more accurately completed. The colors can also be applied directly without any preliminary tonal underpainting.

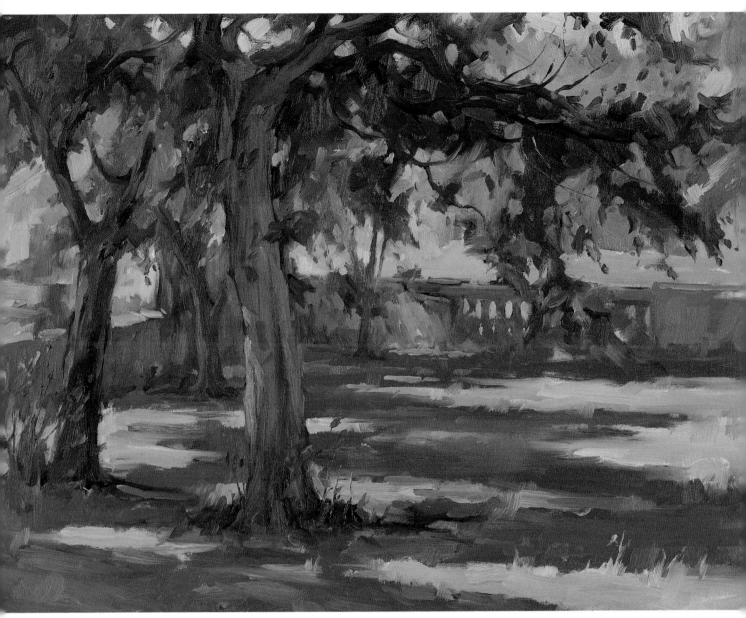

Trees and Grass, 1985. OIL, 12″ × 16″ (30.5 × 40.6 cm)

I decided to develop this painting around the effect of sunlight in the trees and its definite shadow pattern on the grass and wall. The open and much lighter space of the background provides a good contrast for the darker masses of the middle and foreground. Notice how the darks group themselves together throughout the composition and help direct the viewer's glance. When I started this painting, I used a tonal approach and developed my colors on a strong dark and light arrangement. This was necessary because I wanted to establish and keep the pattern of sunlight and shadow before it changed.

Using the Effect of the Light

Tractor in Shadow, 1976. OIL, 12″ × 16″ (30.5 × 40.6 cm)

Painting outdoors enables the artist to directly observe and study the many different effects of light present in nature. Even though there are other influences that may affect a subject's appearance, the first and most important influence is how the light affects it. In this painting, I was greatly impressed by the brilliant effect of sunlight on the grass and how it reflected back into the shadow area, illuminating the old rusting tractor. Although I did use some brushwork to begin the painting, I completed it mostly with a painting knife. This enabled me to apply the paint in a manner that gave me the brilliance and sparkle of sunlight as I had seen it.

TONAL ARRANGEMENT. The dark and light contrast between shadow and light areas is an important tonal feature of the lighting effect in the painting at left. For maximum contrast, the colors I used in this painting were matched to this tonal arrangement. I used a more intense yellow-green in the sunlit grass areas, balanced against a darker and more neutral shadow mass. Remember that intense colors in a picture can be made to look much brighter by balancing them against larger areas of more neutral colors. Besides depicting the effect of sunlight, using the correct tonal arrangement is an important part of correctly showing any type of light effect.

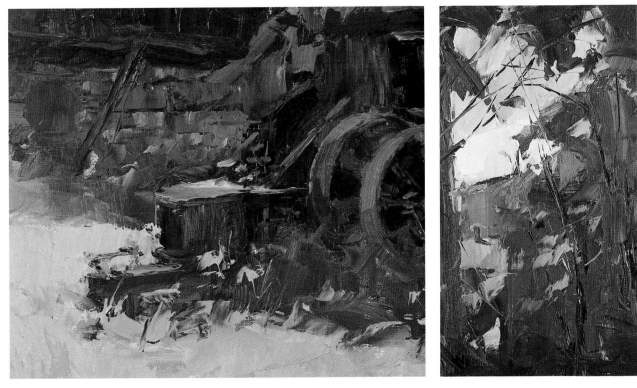

TECHNIQUE. The way oil paint is applied during the actual painting process has a lot to do with achieving a certain effect of light. In these details you can see the different ways of applying paint that were used. A thinly applied dark shadow color was first worked in with a brush and a painting knife. With the knife held flat and well-loaded with paint, crisp strokes of light yellow-green were applied over the dark edge of shadow on the grass. The paint was allowed to break across the shadow freely, giving the sunlit grass a brilliant and crispy effect of light. A heavy application of a light pink-gray color brought the edge of the tractor out into the sunlight from the darker shadow mass. Some areas of the tractor and background in shadow were first applied with a brush and then a warmer reflected light was painted over them with a knife.

Oil paint applied with a painting knife used in different positions.

Creative Use of Outdoor Sketches

Being inspired by something depends not only on how the artist responds to what is seen; it also requires the use of imagination. The artist's imagination is the one thing that can take an ordinary everyday subject and turn it into something extraordinary. Painting or drawing small thumbnail sketches is an excellent way to develop your imagination and also to obtain valuable material for possible finished paintings. Always observe things directly from life and make your sketches then or later from memory. When you see something of interest, no matter what it is, sketch it out quickly several times. Make each sketch different in some way even if it is only changing a tone value or edge. Be honest with yourself when sketching outdoors and always trust your own feelings about a subject.

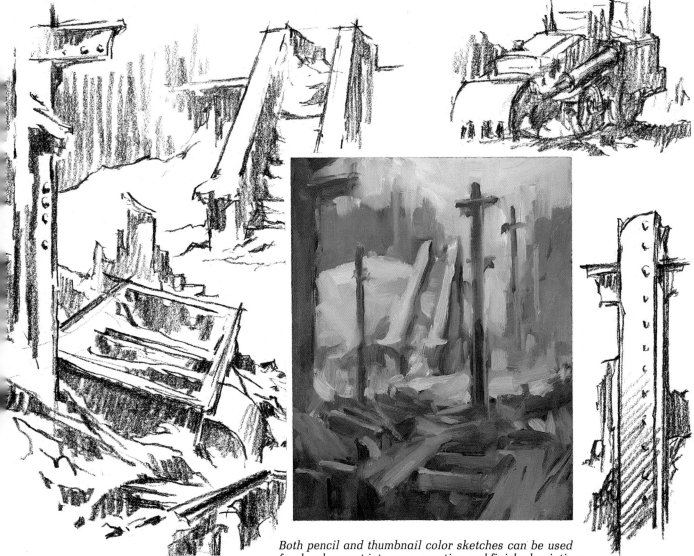

Both pencil and thumbnail color sketches can be used for development into more creative and finished paintings.

That Which Once Was, 1985. Oil, 24″ × 30″ (61.0 × 76.2 cm)

I made many sketches of this building while it was being demolished, but I was especially inspired early one morning when it was deserted after the workmen had finished tearing down all the floors. By using the strong compositional principles of linear perspective and good tonal arrangement, I was able to capture the deeper meaning that the wreckage suggested to me. Whenever I sketch outdoors, I always trust my own feelings about a subject and I allow those feelings to direct me in my painting.

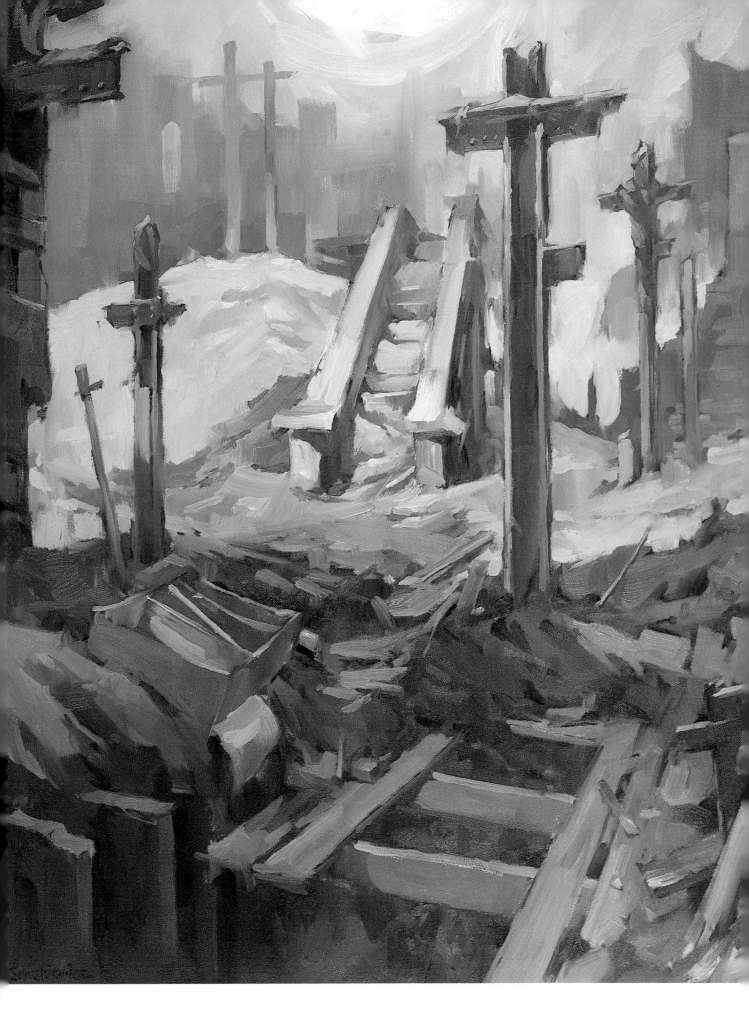

Outdoor Thumbnail Sketches and Their Use

Painting directly out of the paintbox is an excellent way to do thumbnail sketches. Two or three quickly rendered sketches can be done on one 12″ × 16″ painting panel held in the lid of the box. The outdoor thumbnail sketch can be a tonal study in one color or it can be a small full-color study. It is important to remember that these sketches should capture your ideas in the clearest and most direct manner possible.

Using a paintbox to do thumbnail sketches

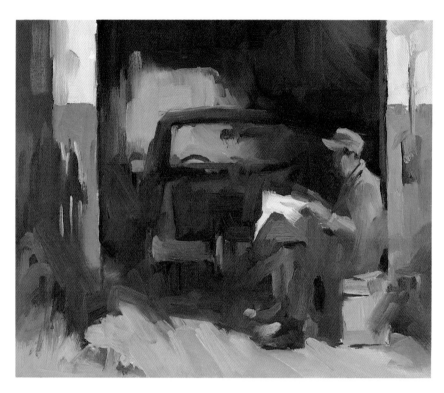

Tonal study. *In poor light or when time is limited, it can be very helpful to do a tonal study in sketch form. If you work out a good tonal arrangement and balance, it can be used as a beginning for a possible painting. A quickly rendered but good tonal study will also enable you to immediately visualize your ideas. Doing tonal studies is a good way of working from memory as well as from life.*

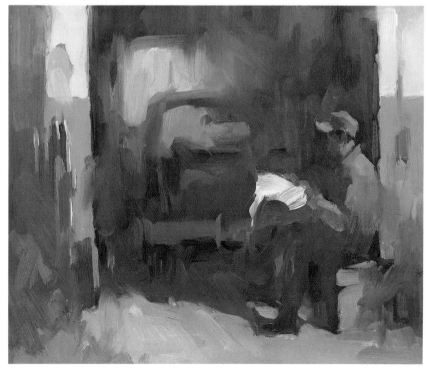

Color study. *Working out a preliminary color study in sketch form can help you develop a painting. A simple but well-done color study can show you how your ideas will look in completed form and help prevent unnecessary errors. When beginning a color study, first decide on a basic color harmony. The color harmony in this study is built around the color blue. In the finished painting, you can still see its strong influence.*

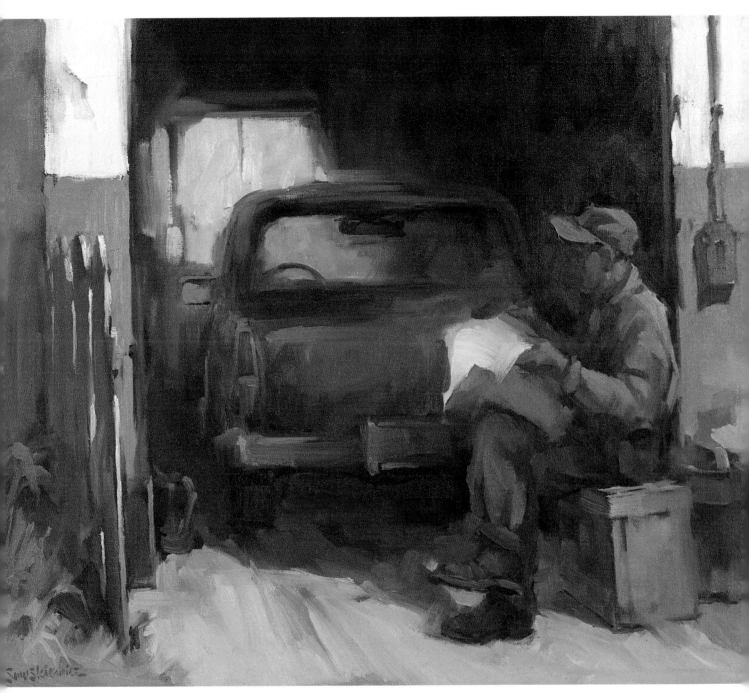

Waiting at the Garage, 1983. Oil, 20″ × 24″ (50.8 × 61.0 cm)

DEVELOPING A PAINTING FROM OUTDOOR THUMBNAIL SKETCHES

When doing an outdoor thumbnail sketch for possible future use, make sure you put all the correct tonal information down first. Then, if time permits, indicate the basic color harmony and balance. Sometimes the original colors indicated in the sketch can be modified or adjusted to better show how the subject was seen. When an artist begins to use a thumbnail sketch, the simple basic tonal and color construction features of the subject will give direction and guidance. The painting can be blocked in using information directly from the sketch. However, in order to finish the painting, you must rely on your feelings and impressions. A finished painting is not necessarily always a detailed picture; a painting is finished when it clearly shows how you saw and felt about a particular subject.

Using Brush Techniques in Outdoor Painting

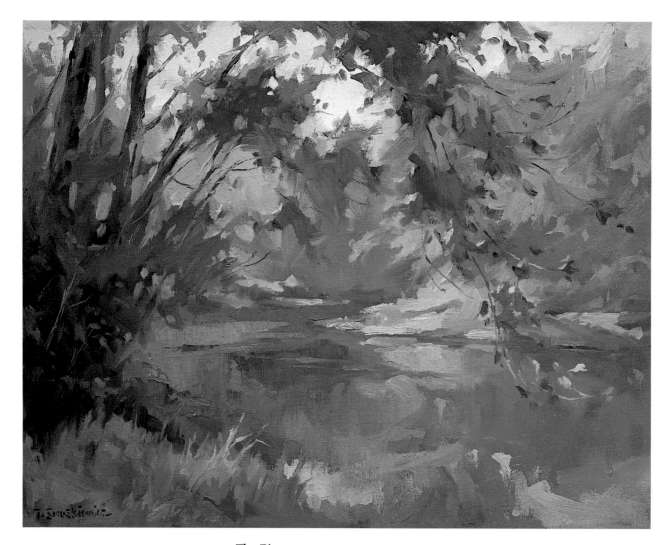

The River, 1983. OIL, 14″ × 18″ (35.6 × 45.2 cm)

I used the direct approach in this painting. I started by first rubbing a thinned-out green color over the whole canvas. After indicating the major areas of tonal change, I cleaned out the lighter areas with a turp-dampened rag. Since I was working directly from nature, this enabled me to establish the tonal arrangement at the very beginning before it changed. I basically used the wet-into-wet technique of painting. This type of brushwork was useful in depicting some of the rhythmic qualities in the foliage and also the reflections in the water. Even though I painted in the darker and middle tone colors first in much of the picture area, it was also important to indicate some of the stronger lights as well. When painting wet-into-wet, it is important to frequently wipe the excess paint from the brush. Remember that as you apply paint on a wet surface, the brush will also pick up some of the surface paint. If too many brushstrokes are made without wiping the brush clean, the colors can become excessively grayed out and muddy looking.

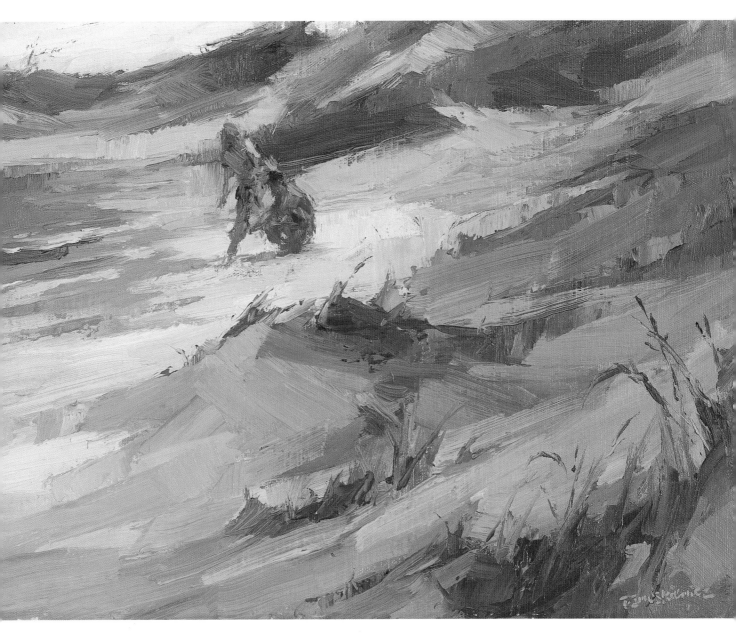

Couple on the Beach, 1976. Oil, 12″ × 16″ (30.5 × 40.6 cm)

To obtain the full benefit from brushstrokes, it is important to leave them alone after they are made. Every time a brushstroke is made, it is adding something to the appearance of the painting and also to the personal effect that the artist envisioned. When I painted this beach scene, I used my brushes strongly to create form and at the same time give movement and feeling to the painting. The detail to the right clearly shows the construction of the figures with bold and direct brushwork. When simplicity of handling is desired in a picture then use as few strokes as possible to paint form.

Chapter Nine
PAINTING OTHER SUBJECTS

Any subject or idea that you have can be developed into a finished painting if you use good principles of composition and color and paint your picture with sound painting techniques. In this chapter, which is essentially a gallery of paintings of a variety of subjects, I will show how I applied the basic principles of composition and color that we have covered so far.

COLOR TEMPERATURE OF LIGHT AFFECTS THE APPEARANCE OF COLOR.

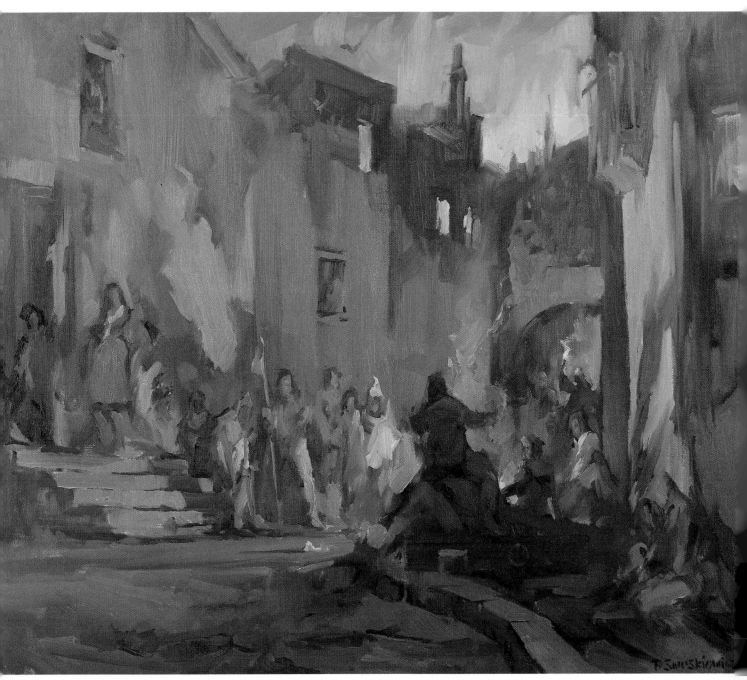

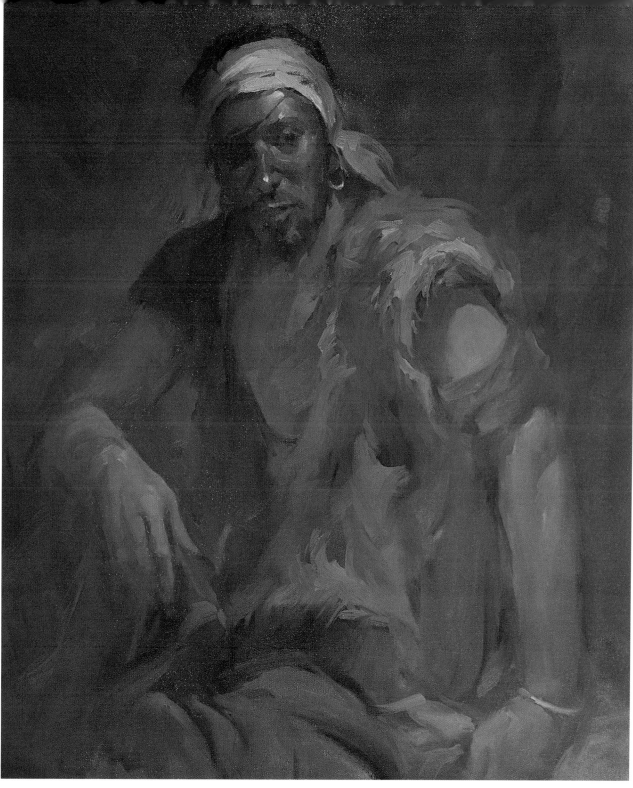

The Court of Miracles, 1985. Oil, 20″ × 24″ (50.8 × 61.0 cm)

In this painting, I used a strong arrangement of dark and light tones plus a definite harmony of warm and cool colors. This helps capture the mysterious atmosphere of a firelit night composition. Since actual fire is too bright, I achieved the effect of brightness by showing the strong light of the fire rather than the fire itself. Notice the strong pattern of light and shadow on the walls and figures and how much warmer the light is nearer the fire. The viewer's glance is led into the picture on the right along the slightly curving curb stones and then through the rest of the composition, following the dark and light pattern on the right and left.

Man with the Eye Patch, 1985. Oil, 20″ × 24″ (50.8 × 61.0 cm)

A costumed figure always has the potential for being an interesting subject for a painting. With a costume composition, the artist can use color and the texture of material as effective parts of the painting. Here, I used a harmony of red and orange-red balanced against neutral colors. This composition was first developed around a strong dark and light arrangement. The light source is from above and to the side. This puts the head in a very dramatic light. One side of the head is in total shadow while the other side is in a strong light with a good highlight on the forehead. Definite brushwork was used to paint the different textures in the clothing. Compare the robe on the shoulder with the light-colored headscarf and the red rag around the arm.

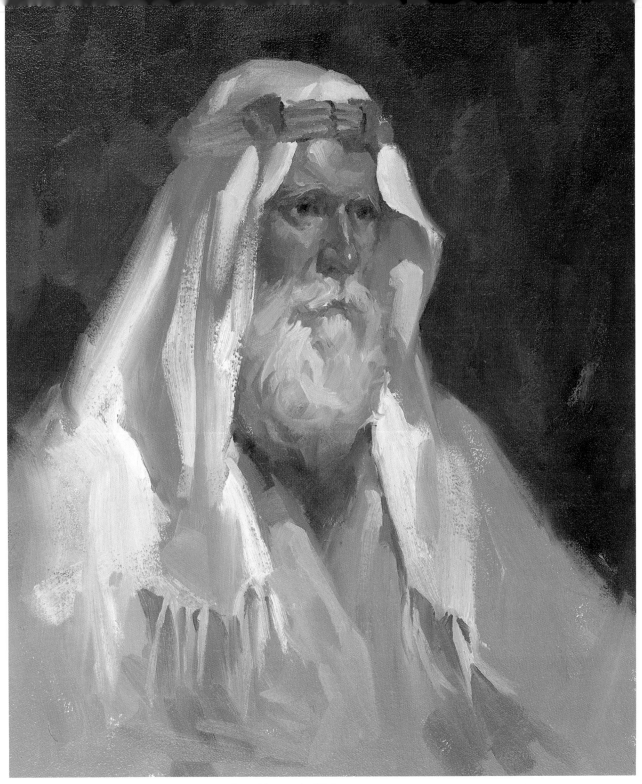

The Old Man in White, 1985. OIL, 20″ × 24″ (50.8 × 61.0 cm)

In this painting, the surface texture of the canvas is one of the important things that contributed to the over-all effect. Another important part of the painting is in how brushwork was used to develop different forms. The basic composition of this picture was first constructed on a solid dark and light tonal arrangement, then a pleasing color harmony of warmer orange colors balanced against more neutral colors and cooler blues was added. Edges are painted hard and soft in a balanced manner throughout the painting, and the masses of darker tones hold together in a strong pattern. The white shawl provides a very important balance for the more intense colors of the face.

This detail of the painting on the opposite page clearly shows the use of brushwork in painting the face. The rougher texture of the canvas shows in the broken brushstrokes in the shawl. Painting on this rougher texture also forced me to use more oil paint in building up the various forms of the features. The beard was first blocked in with a middle-toned color of warmer yellow-gray. The lighter colors of the beard were then brushed in while the undercolor was still wet. Even though I used a variety of directions with the brushwork, the basic form of the beard is still painted with solid dark and light construction.

I used my brushes with a definite direction and purpose in constructing the different forms in this painting. This detail shows the way that the edge of the shawl was painted. Using a little painting medium with the color, I charged the brush fully with paint and applied the stroke, leaving it alone and not going back over it again. By avoiding additional and unnecessary strokes, I was able to construct form in a sure manner. Some edges were softened and lost by wet-into-wet painting in similar tonal values. Sometimes a lighter color was brushed and dragged over a darker undercolor while it was still wet. When painting like this, remember to wipe out the brush frequently to avoid muddy-looking color.

The Warrior, 1985. OIL, 24″ × 32″ (61.0 × 81.3 cm)

In this costumed figure composition, red is a basic part of the color harmony and it contributes much to the effect of this subject. I painted with sure and definite brushstrokes. This can be especially seen by studying the way the head has been painted. Notice the variety of color used in the head and the strong way in which it was painted. This painting was first blocked in with thinned-out colors to establish the larger forms. As the painting progressed, heavier applications of paint were made by boldly laying one color over another.

The First Artist (prehistoric man), 1985. OIL, 20″ × 24″ (50.8 × 61.0 cm)

Since firelight provides the main source of light in this composition, the basic color harmony is built around orange, influenced by its adjacents, red and yellow, and for balance, neutrals, and its complimentary color of blue. To bring more attention to the cave and the central figure on the back wall, I showed the effect of firelight rather than the actual fire itself. The warm temperature of the light shows its influence on everything it strikes in the cave, and is enhanced by the much cooler blue daylight coming in from the cave entrance. The dark and light tonal arrangement consists of cool darker shadow areas constrasting with the warm light that comes from the fire. Many individual parts of this picture are unified by being part of either the dominant dark mass or the smaller light mass.

The viewer's glance is led into the picture so that it sweeps across the back wall and the central figure. Notice how the edges of some of the dark and light masses also give direction. Even some of the individual forms of rocks and figures in the foreground were painted in such a way as not to impede the sweep of the viewer's gaze.

The Burning River, 1978. OIL, 22″ × 28″ (55.9 × 71.1 cm)

Here, the full fire is boldly painted to bring the viewer's attention immediately to the burning riverboat. This picture is constructed on the strong compositional principles of tone and color. The tonal arrangement is basically in the darker and middle tones with smaller light areas, which helps reinforce the effect of the firelight. The warmer colors of orange and yellow are balanced against more neutral colors as a basic harmony. Even the influence of line is used in this composition, as can be seen in the foreground masses and also in the riverboat and fire.

The Head in the Desert, 1984. OIL, 22″ × 28″ (55.9 × 71.1 cm)

This allegorical painting is constructed on the compositional ideas of line and mass. The large head in the background is placed in the dynamic center of the picture rectangle. This, plus the line and tonal arrangements throughout the picture, helps direct the viewer's glance into the background and to the head. Some of the individual figures are unified with the rest of the picture by grouping them together with a similar mass of tone. This can be seen in the lower righthand side and also in the background on the shadow side of the head. Neutral and gray colors were used to give this painting its particular effect, the effect of light comes from the tonal arrangement and the one strong direction of the primary light.

Chapter Ten
PASTEL PAINTING

Artists using pastels can approach their subject in the same way as those using oil paints or watercolors. The color and tonal principles are the same. The difference is in the medium itself and how it must be used to achieve the desired effect. The idea of showing form through color and tone is the same in any painting medium, as are the principles of good composition. Problems could arise only if an artist were to attempt to duplicate the technique of one painting medium in another. Each has its own special qualities and techniques.

Pastels are capable of giving a full range of color and tone and should not be restricted to lighter and more airy type of color effects. Darks can be put in boldly and with strength. If the individual working technique and color effects of pastels are made use of, they can be freely used as a painting medium to achieve a great number of different effects.

Pastels are a dry painting medium and come in round or square sticks. The color pigment used in their manufacture is generally the same basic pigment used to make oils and watercolors. The primary difference is in the way the color pigment is bound together. Since pastels are applied dry, in strokes that must be readily deposited on the painting's surface, the pastel stick has very little binder to hold it together.

Holding the pastel stick on-end when applying it will produce linear strokes, either bold or delicate. By using it sideways, you can get broad, full strokes with great covering power. Some of these basic strokes can be seen in the details opposite.

Autumn Landscape, 1985. PASTEL, 16″ × 20″ (40.6 × 50.8 cm)
The technique used in painting this pastel rendering was to first lay in large areas of basic color without allowing too much of a buildup of pastel on the surface. The color was gradually developed with further applications of pastel, using a variety of different strokes.

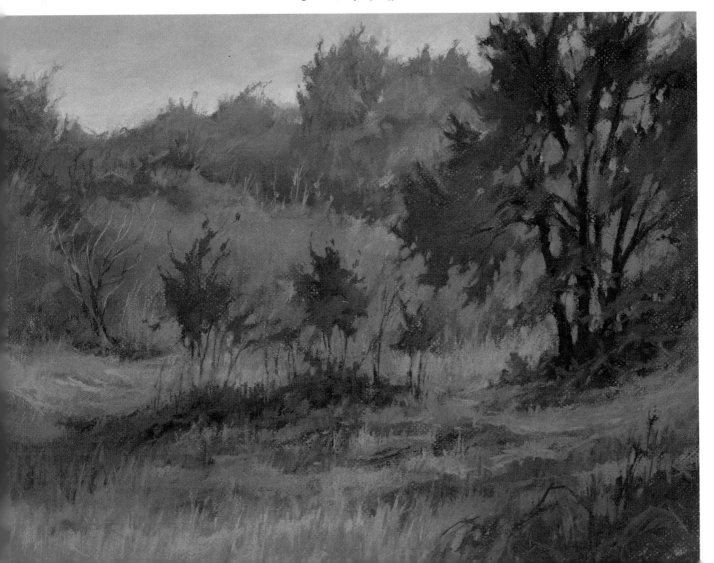

In this detail of the center section of the painting opposite, you can see a number of ways of using pastels. First, two basic groups of dark and light colors were applied. Holding the pastel stick sideways, large and simple areas of undercolor were blocked in without allowing excessive buildup of pastel pigment on the surface. This is important if later applications of color are to go on without difficulty.

COLOR AND TONAL PRINCIPLES ARE THE SAME IN PASTELS AS THEY ARE IN ANY OTHER PAINTING MEDIUM.

Some areas were lightly rubbed together with a finger. The darker forms of the trees and grass were put in with definite strokes of color. Attention was paid to edges and tonal relationships. Sometimes the pastel stick was held on end for thin and sharply indicated linear type strokes.

Pastel Painting Material and Its Use

Since pastel colors have very little binder in them, a pastel rendering depends on the surface of the paper to hold the color. Paper or other materials with too smooth a surface will not work well with pastels. Pastels require a paper with some surface texture, whether it is subtly surfaced or somewhat more textured. There are several popular types of pastel paper made in different surfaces and a wide selection of colors. Besides the regular textured paper there are also velour and sanded papers.

A fixative may be lightly sprayed over the painting to help the pastel adhere to the surface. However, caution is advised in spraying fixative on a pastel painting: be sure to keep the spray can moving, with an even side-to-side motion to avoid wet spots. It is better to spray several light applications than one heavy one. Too heavy an application of fixative can darken or change the colors. A good approach would be to fix the initial block-in and then finish the painting with lightly applied colors that are not fixed. Naturally, then, the finished painting must be protected in some way. Double-matting it and placing it behind glass should be sufficient if it is to be exhibited. Keeping your unframed pastels in a rigid portfolio with protective paper between them and being careful when handling them should be adequate protection.

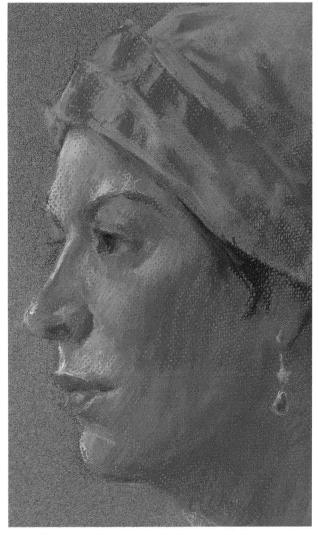

A good approach to using pastels is to first lightly lay in a basic dark and light color arrangement. Avoid putting in strong highlights at this beginning stage. Since I worked on a middle tone gray paper for this detail of the painting shown on the opposite page, both dark and light tonal areas were easier to judge. After this first block-in of color, smaller strokes of color were applied directly over the underpainting to develop the various forms. While applying this color, the correct tonal value and color temperature was always used.

Pastel colors may be applied lightly in some areas, allowing the colored paper to show through for good edge effect. Other places can receive a much heavier application of color. In the detail shown here, you can see how I built up the red on the dress and necklace and also the upper chest area below the collarbone with heavier strokes of color.

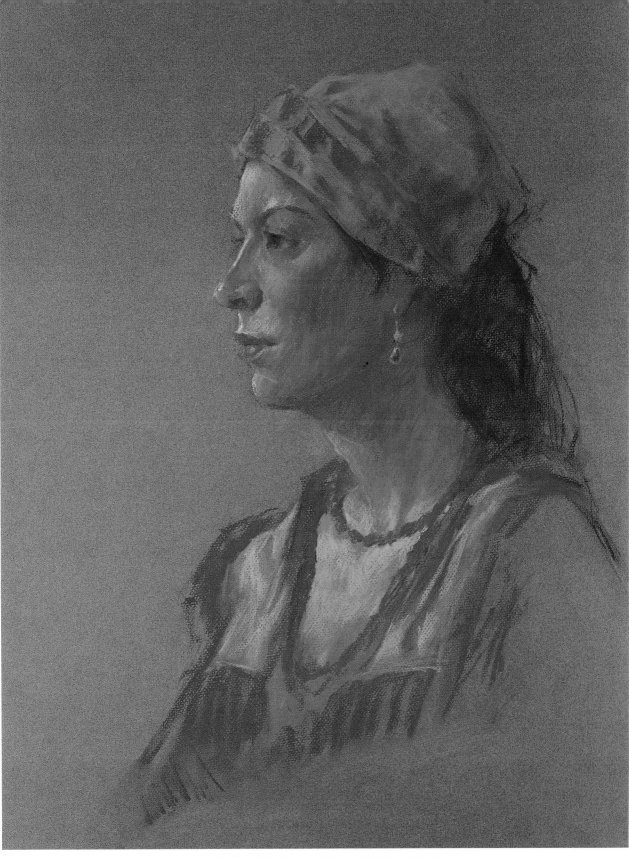

Kelly, 1984. PASTEL, 18″ × 24″ (45.2 × 61.0 cm)

This head study was started with a simply rendered line drawing in soft charcoal. Only a few lines to show the larger masses of darks and lights were indicated in this initial drawing. The first application of color was laid boldly into the main dark and light tonal areas and rubbed slightly with the fingers. Additional color was applied over this underpainting, using a variety of individual strokes to develop the right forms. The gray paper was kept as a general background and allowed to show through in some of the shadow areas, giving a certain amount of unity to this painting.

Starting a Pastel Painting

Just as an oil painting can be started in three basic ways, so can a pastel painting. In using pastels on a toned paper, the artist can combine a line and a tone approach at the very beginning of the painting. By selecting a toned paper with a color compatible with the color harmony of the subject, the artist can even use color in the very first stages.

The procedure used in the finished block-in of the market scene on the opposite page was as follows: Using soft charcoal, some of the main proportions were indicated on a somewhat neutral middle-tone paper with line work. A line and mass drawing was then sketched in with a dark warm color like Indian red. Some of this original drawing can still be seen.

Some color was then applied. In order to keep a depth and richness to the color, I blocked in much of the colors first in the stronger middle range of tone. In the first stages of painting, I applied the lighter colors as sparingly as possible. I laid the color in with a firm but even application, using the side of the pastel to obtain simple but broad coverage. To obtain more definite edges or line effect the pastel may be held on end.

The sketch of the boat on the lower part of the opposite page was blocked in using a similar approach except that the line and mass drawing was first put in directly with blue pastel.

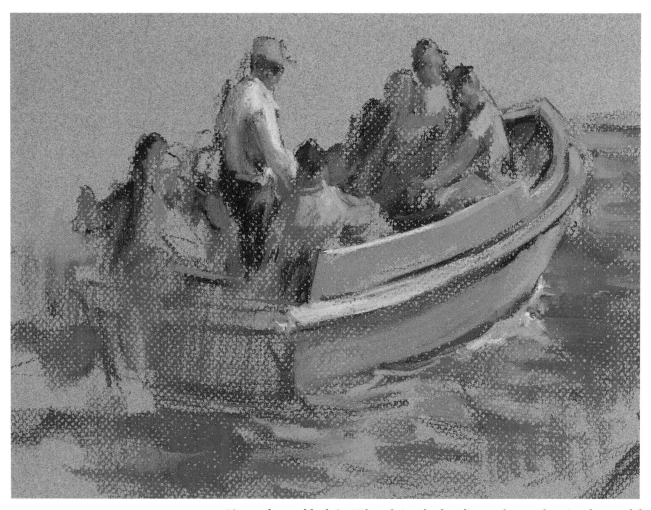

Line and mass block-in. When doing the first line and mass drawing, be careful not to become involved with too detailed a rendering. Try for simplicity and accuracy. The simplicity of the first lay-in of color can be seen in this detail of the boat block-in from the opposite page. The colors were applied directly to the initial line-and-mass drawing, keeping in mind the color temperature of the main light source. Blue was used as a beginning color. This first blue line and mass beginning can be seen on the right side of the painting on the opposite page.

Market and Boat Block-In, 1985. PASTEL, 19″ × 25″ (48.3 × 63.5 cm)

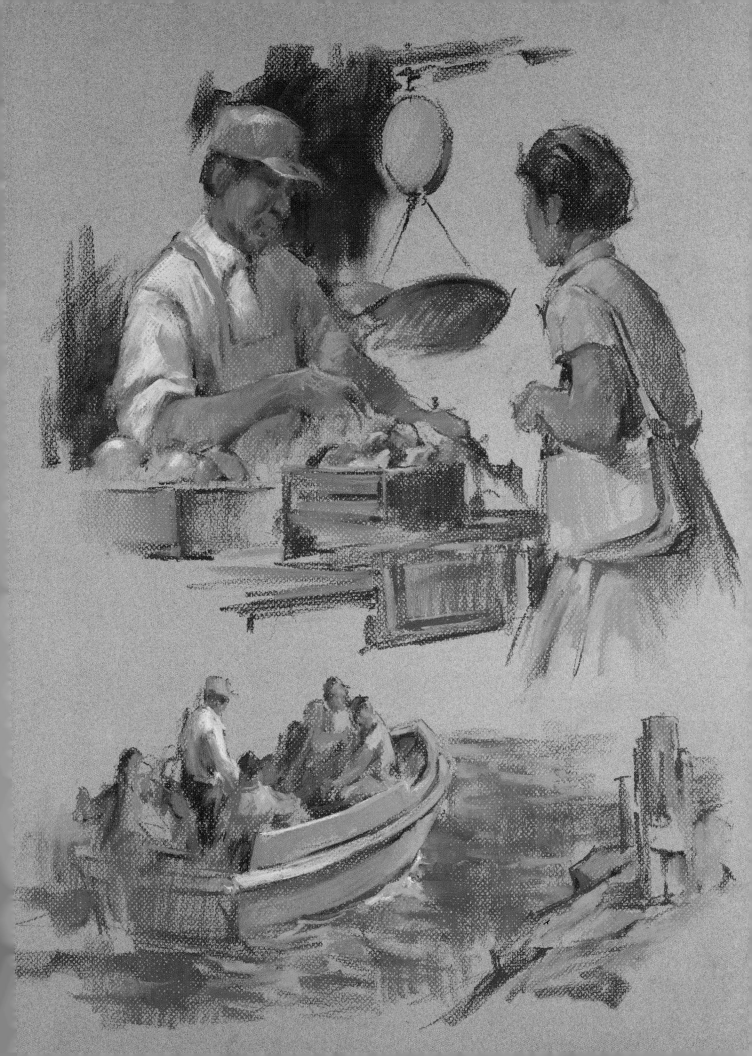

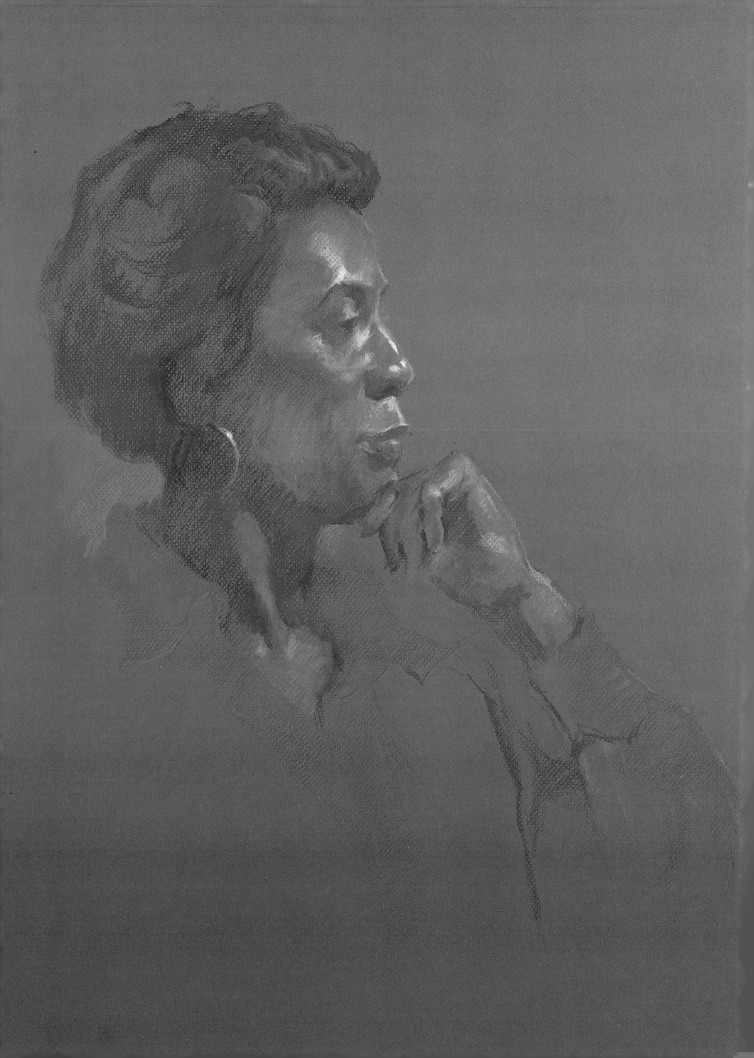

USING THE PAPER'S COLOR

Since pastel is a painting medium that is usually used in a direct way, it is advantageous for the artist to use the color of the paper whenever possible. Some careful consideration of the final effect desired in the picture will help in the selection of the color. This would mean thinking of the basic colors of a subject and also what type of light is illuminating it. For the painting shown below, I selected a blue paper, which is especially effective as contrast to the warm autumn colors of the subject. All the lighter areas in this picture have a strong influence of blue from the moonlight. The warmer colors are stronger in the middle and dark tonal range only. The picture's color harmony and balance is firmly constructed on a definite dark and light tonal foundation. All effective color use depends on a good tonal beginning.

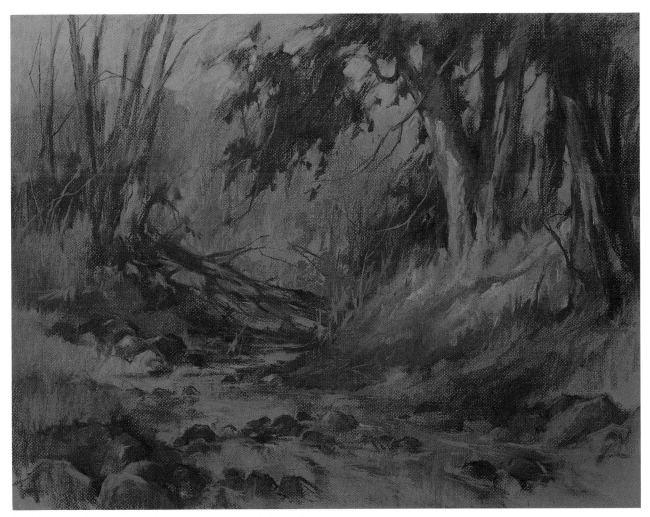

Moonlight and Stream, 1985. PASTEL, 19″ × 25″ (48.3 × 63.5 cm)

THE COLOR OF PAPER CAN BE EFFECTIVELY USED IN DEVELOPING A PASTEL PAINTING.

This painting was started with a good line and mass construction. I used a deep mars violet color to sketch it in. Once that was established, I began to work in the warmer colors in the dark and middle tonal areas. The blue color of the paper was used as a balance to these warmer colors and not completely covered over so that it still showed through. I only started to put in the cooler lights after a good dark and middle tone foundation was established.

Arlene in Blue, 1985. PASTEL, 18″ × 24″ (45.2 × 61.0 cm)

Sketching with Pastels

As a sketching medium, pastels give excellent results because of their wide range of color effects and their convenience and portability. With a carefully selected assortment of some 50 or 60 colors, a full color range, as well as a wide range of light effects can be indicated. A pad of pastel sketching paper or loose sheets attached to a small drawingboard and a lightweight folding campstool to sit on—all easily carried in a portfolio—are the only other things you will need to sketch with pastels. Outdoor sketches with pastels can be either detailed study sketches or quicker thumbnail sketches.

Pastel Sketches, 1985. PASTEL, 19″ × 25″ (48.3 × 63.5 cm)

The landscape sketch shown at top is a 12″ × 16″ study that I spent about an hour and a half on. After selecting my subject and deciding on the right composition, I sketched in the basic line and mass construction, using two dark colors—mars violet and deep olive-green. Using a middle-tone gray paper allowed me to achieve a wider and more unified effect of tonal range at the very beginning. If the paper is the right color it can also immediately be used as part of the sketch. Next I worked in the stronger colors of the middle tones. Much of the block-in colors can be in the middle tonal range. This is what will give strength and depth to the color of the painting. Avoid using the lighter colors too heavily, especially at the start.

The figure composition sketch shown at bottom is a quickly rendered thumbnail sketch. It is about 10″ × 14″ and it took me no longer than thirty minutes to sketch. When doing a thumbnail sketch, it is necessary to work accurately but rapidly. Accuracy results from first indicating only the important construction features of the subject such as line and mass and basic colors. The purpose of this type of sketch is to quickly put your ideas down in visual form without developing them into a detailed finished study.

When blocking in or starting a sketch, lay in only the masses of dark and light colors. Edges and different line effects can be put in later by directly applying color over the mass block-in. This can be seen in this detail of the right side of the upper pastel sketch on the opposite page.

This detail of the bottom sketch on the opposite page shows the simplicity of color indication in a quickly rendered sketch. Only the important construction forms of the figures were put in. Detail was avoided. Sketching in pastel on a toned paper can help significantly in almost immediately visualizing the final effect.

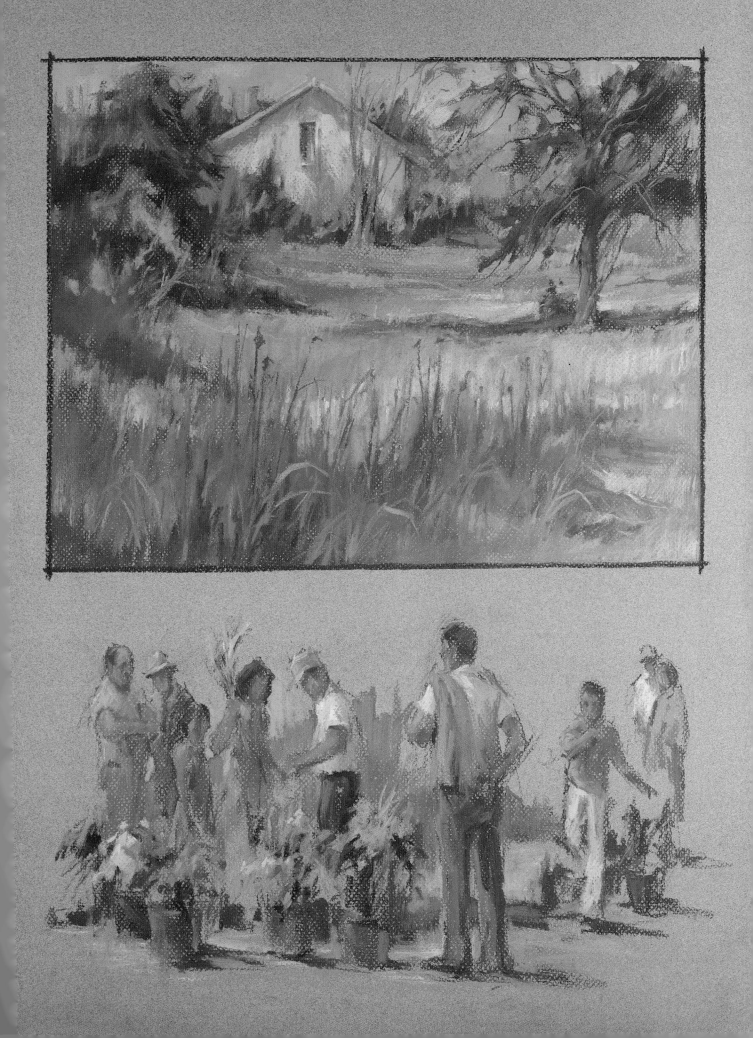

Man with the White Beard, 1985. PASTEL, 16″ × 20″ (40.6 × 50.8 cm)

A pastel painting is developed by first blocking in the larger masses of color, using the pastel stick held sideways. Sometimes just color applied over color gives the right effect. At other times some rubbing with the fingers is necessary. Stronger and more sharply defined edges can be indicated by using the stick held on end. The pastel painting shown above was painted with this basic technique.

The Ice Skaters, 1985. PASTEL, 16″ × 20″ (40.6 × 50.8 cm)

Many different light effects and color arrangements can be shown by using pastels. In this painting, I wanted to show the effect of winter sunset light as part of the composition. The use of pastels enabled me to easily distribute the basic color harmony of red, violet, and blue throughout the composition. In the detail at right, you can see the color strokes used to build up the figures and background. The color was first applied in flat areas by using the pastel stick sideways. Stronger linear type strokes and accents were then put in directly over this to develop the different forms.

Conclusion

Creative painting is not just clever paint handling and technique. When an artist paints a certain subject creatively, he or she is using good composition and color in a way that clearly shows a unique way of seeing that subject. There are many different ways of putting paint on a canvas, but each of us sees a subject at any one time only in one individual way. It is up to the artist to choose a technique of painting that will show a subject as it is truly seen.

It does not matter what subject the artist chooses to paint, what matters is how that subject is painted. Any subject can form the basis for a good painting. There are no cliché-type subjects for painting, there are only cliché-type artists. If fault is found with the subject in a poor painting, then the critic is looking in the wrong direction; most likely it is the artist who painted the picture who is at fault for its failure.

Every day we see and come into contact with a variety of different things that have the potential of being good subjects for paintings. How these possible subjects are used depends on the way they are seen and interpreted by the individual artist. Be honest with what you see and always trust your own judgment and feelings about your subject!

Winter Landscape, 1983. OIL, 12″ × 16″ (30.5 × 40.6 cm)

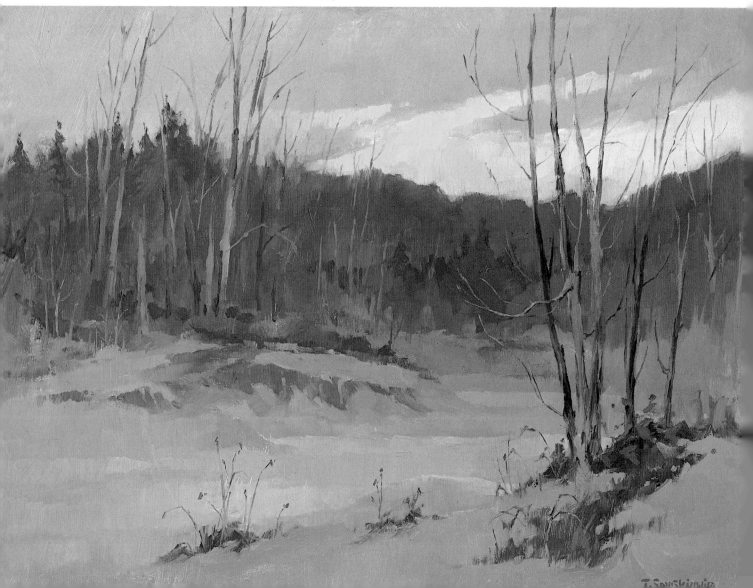

Index

Designed by Bob Fillie
Graphic production by Ellen Greene
Set in 10-point Vermilion